The Pastel
Artist's Bible

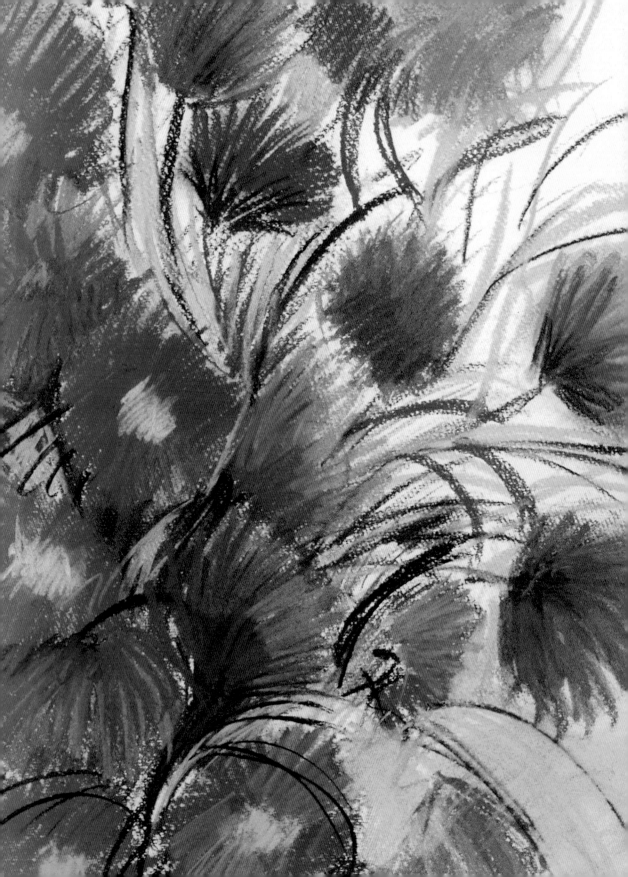

The Pastel
Artist's Bible

An essential reference for the practising artist

edited by
Claire Waite Brown

Search Press

A QUARTO BOOK

Copyright © 2006 Quarto Publishing plc
This edition published in 2016 by
Search Press Ltd
Wellwood
North Farm Road
Tunbridge Wells
Kent TN2 3DR

ISBN: 978-1-78221-394-9

Conceived, designed and produced by
Quarto Publishing plc
The Old Brewery
6 Blundell Street
London N7 9BH
www.quartoknows.com

QUAR.TPAB

Project Editor: Mary Groom
Art Editor: Julie Joubinaux
Designer: Tanya Devonshire-Jones
Assistant Art Director: Penny Cobb
Art Director: Moira Clinch
Publisher: Paul Carslake

Manufactured by PICA Digital, Singapore
Printed by Toppan Leefung Printing Ltd, China

Parts of this book have previously
been published in *The Encyclopedia of
Pastel Techniques*, *Pastel School* and
Masterstrokes: Pastel.

Contents

Introduction 6

Materials 8

Types of pastel 10
Looking after your pastels 12
Paper textures 14
Paper colours 16
Other equipment 18

Colour 20

Colour principles 22
Basic palette 26
Colour mixes 29
Using greens 38
Using browns and greys 40
Mixing skin tones 42
Using skin tones 44

Basic Techniques 46

Working practice	48
Side strokes	50
Linear strokes	51
Tutorial: Using basic strokes	52
Gestural drawing	54
Blending	56
Surface mixing	60
Broken colour	62
Hatching and crosshatching	64
Feathering	66
Scumbling	67
Colouring the ground	68
Texturing the ground	70
Preparatory drawings	72
Building up	74
Tutorial: Building a painting	78
Highlights and shadows	80
Tutorial: Colour accents	84
Erasing	86
Fixing	88

Further Techniques 90

Masking	92
Wet brushing	94
Impasto	96
Sgraffito	98
Underpainting	100
Charcoal and pastel	102
Coloured pencil and pastel	104
Watercolour and pastel	106
Gouache and pastel	108
Acrylic paint and pastel	110
Oil paint and pastel	112
Resist techniques	114

Subjects 116

LANDSCAPE	118
Composing a landcape	118
Light and landscape	122
Atmosphere and landscape	124
Tutorial: Atmospheric landscape	126
Skies	130
Water	132
Trees	134
Flowers and foliage	136
URBAN SUBJECTS	138
Buildings	138
Depicting details	142
Urban settings	144
Tutorial: Urban landscape	146
STILL LIFE	150
Found groups	150
Fruit	152
Tutorial: Painting fruit	154
Flowers	158
Floral still-life groups	162
PEOPLE	166
Portraits	166
Tutorial: Painting a portrait	170
Figures in action	174
Figures in context	176
Tutorial: Painting figures in a setting	178
Figure groups	182
ANIMALS	184
Animal studies	184
Tutorial: Animals in action	186

Index	**190**
Credits	**192**

Introduction

When you open a drawer of pastels in a specialist art stop, the glow of colour that greets your eye seems to offer a direct invitation to your hand. Pastels are made from pigment held together with a tiny amount of binder, so using them is like using pure pigment, and they possess a brilliance of colour unrivaled by any other medium. Perhaps this is why pastel is becoming such a popular painting medium, prized by both amateurs and professionals for its rich colour, its versatility and its easy handling.

▶ **Learn about different types of pastel**

Pastel is the most direct of all the painting media, but that does not mean it is problem-free. Any good painting is the product of thought, planning and a thorough knowledge of the medium that comes from practice and experimentation. *The Pastel Artist's Bible* is here to help you grapple with all of the above, from the pastels themselves and how to use them, to dealing with colour and composition.

This information-packed book is divided into five sections. The first, Materials, introduces you to the range of pastels and papers that is available to you, with examples of how paper textures and colours can affect your work. The Colour section looks at the principles of colour and gives suggestions for mixing colours and choosing a basic palette – especially important as manufacturers produce a bewildering array of coloured pastels.

The techniques of pastel work are split into two sections. Basic Techniques starts at the very

▶ **Useful tips on colour**

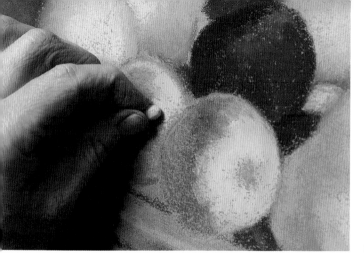

◀ **Discover new skills**

beginning, looking at some basic strokes and ways to mix pastels on the paper, and progresses to textural techniques and using highlights and shadows to ensure your painting has depth. In Further Techniques you will learn how to manipulate the medium in interesting ways to create unique results and may be encouraged to mix pastels with other painting media.

The final chapter, Subjects, is designed to help you learn by example and features the work of many and varied artists, in subjects ranging from landscape and still life to people. While the best thing about being an artist is enjoying what you do and experimenting with your own style, looking at how other artists work can help you

discover and develop your own interests.

Developing skills is important but what matters even more is that you take pleasure in what you do. Treat this book as a springboard to launch you into the exciting world of pastel painting.

▶ **Look at paintings by established artists**

Materials

Types of pastel

The four basic kinds of pastel available are soft pastels, hard pastels, pastel pencils and oil pastels. Soft pastels are the most versatile and widely used because they produce the wonderful velvety bloom that is so typical of this medium. Although hard pastels may be used in the initial stages, most people use soft pastels for the bulk of their painting because they are easy to blend and smudge. They create rich painterly effects and can cover large areas quickly. Hard pastels have a firmer consistency because they contain more binder, and, as such, they are generally used in a 'drawing' rather than a 'painting' capacity.

Pastel pencils are more expensive to buy than pastel sticks, but it can be useful to have some to hand for intricate work. Oil pastels are bound with an oil binder instead of gum and they make thick, buttery strokes. Their colours are deeper and more luminous than those of soft pastels – more akin to oil paints.

Pastels, particularly soft ones, vary considerably according to the manufacturer. You may find a certain brand that you prefer for its ease of handling or colour qualities, but it is also possible to mix and match from different selections, so you need not waste pastels if you change brands. Most manufacturers produce boxed sets of selected colour ranges, but the pastels are usually sold individually as well.

Soft pastels

Soft pastels contain very little binder, hence the ease with which they transfer colour to the support and the brilliance and rich texture of the colours. They are usually round in shape, but are available in a variety of sizes. Some of the high-quality pastel ranges contain literally hundreds of colours.

Because soft pastels contain little binder the powdery colour can seem to spread uncontrollably, and it is aggravating when a fragile stick snaps or crumbles in the middle of a stroke. This can lead to a cautious approach, but the best results come from working freely and decisively.

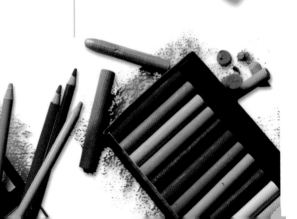

Hard pastels

Hard pastels have a greater proportion of binder to pigment, so they are more stable in use than soft pastels, but do not have such wide potential for varied surface effects. Traditionally they are used for preliminary sketching out of a composition and for adding linear detail and 'sharpening' touches to soft pastel work. You can exploit the linear qualities by using the section edge of the stick or sharpening it to a point by shaving with a fine blade. The colour range of hard pastels is quite limited in comparison with soft pastels.

Pastel pencils

Like hard pastels, pastel pencils are good for fine detail and making preliminary drawings. The 'leads' are typically harder than soft pastels but often softer than hard pastels. Their main advantage is that they are clean to use and easy to control, although they have a relatively limited colour range.

Oil pastels

Oil pastels are quite different from all the other types of pastel and are not compatible with them. Typically, the colours are quite strong and the variation of colour values is restricted. Oil pastel marks cannot be blended in the same way as those of other pastels, but must be softened and spread using white spirit or turpentine.

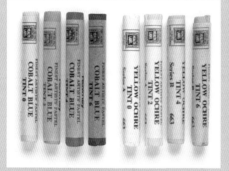

TINT NUMBERS

Nearly all pastel colours are available with different 'values' – darker or lighter gradations of each individual hue. Most manufacturers call these values 'tints', and they are often denoted by numbering from one to ten, the lowest number denoting the lightest and the highest the darkest. To find the colour in its purest form, look for the middle number.

Looking after your pastels

A boxed set of pastels contains a tray of preformed slots that keep the pastels separated from one another. However, if you choose loose pastels you will need to consider for yourself how best to keep them apart so that they remain clean. This may mean buying ready-made grooved boxes or making your own storage devices.

If your pastels do get dirty, which they inevitably will as pastel dust on your hands can easily be transferred to a clean stick, there is a simple way to clean them.

Safe storage

If you do not have a ready-made pastel box, try using corrugated cardboard to line small boxes to keep pastels apart from each other and therefore clean.

Clean storage

If you store all your pastels in one box, line it with ground rice to help keep the sticks separated. The slightly rough-textured rice will also rub against the pastels, removing any dust they have picked up from other pastels or your hands. Clean off any particles of rice before using each stick.

Organized storage

When using a lot of colours it is not feasible to keep each one separate. Instead, try to arrange them in colour groups so that you can quickly pick out the ones you need. Cutlery trays or plastic trays from supermarkets or delis make ideal containers in this situation.

Cleaning pastels

1 However carefully you store your pastels, you can't always keep them clean when you are working. To clean them, put the dirty pastels into a box or bag of ground rice and shake them until the muddy-coloured dust is absorbed by the grain.

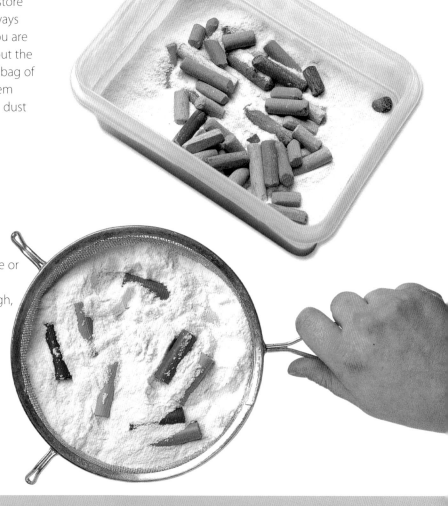

2 Empty the contents of the box or bag into a sieve or colander and the dirty ground rice will fall through, leaving clean pastels.

BREAKING PASTELS

Pastels can be sharpened with a knife, but the point will quickly wear down, and sharpening on sandpaper is wasteful since you lose a good deal of colour. To avoid unnecessary wastage, simply break a pastel stick in half. The freshly broken edge will produce a fine line and the rest of the stick can still be used.

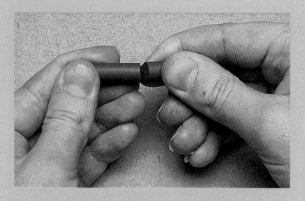

Paper textures

The main requirement of a paper for pastel work is that it has a slight 'tooth', or texture that allows the pastel particles to grip the surface. On a smooth surface the pastel colour will be unstable and as you build up pastel strokes they are likely to smear, or simply not adhere. A pronounced paper grain also contributes to the colour qualities of the rendering, because the pastel does not fill the recessed areas of the grain and the colour of the paper shows through.

Mi-Teintes and Ingres paper are popular choices with many pastel artists, and both are inexpensive and available from art shops. However, there are a few other options.

1 Ingres paper

The textured surface of this paper consists of close parallel lines. It can also feature a fleck in the surface that gives a mottled effect to the colour. Ingres paper is suitable for use with all types of pastel, including oil pastel.

2 Mi-Teintes paper

Mi-Teintes paper is thicker than Ingres and has a textured side, with a pattern like chicken wire, and a smoother side, with a pattern of straight lines. Both sides can be used for all pastel work, including oil pastel. This is a tough paper that can withstand heavily worked pastel.

3 Fine sandpaper

Some pastel painters prefer a stronger texture than that provided by the two standard papers and they work on fine sandpaper. This is the same as sandpaper used by carpenters, but it can be bought from art suppliers in large sheets. Sandpaper is not suitable for working in oil pastels.

4 Pastel board

Pastel board is similar to fine sandpaper but less scratchy. The surface is made from tiny particles of ground cork that hold the pastel extremely well. You may find this paper under the trade names Rembrandt or Sansfix; it should not be used for oil pastel work.

5 Watercolour paper

A rough, cold-pressed watercolour paper – sometimes referred to as 'not' – is also suitable for pastel work, including working with oil pastels. A smooth or hot-pressed watercolour paper, on the other hand, will not accept the pastels.

Effects of paper texture

These two paintings illustrate the difference a paper texture
can make to the final rendering.

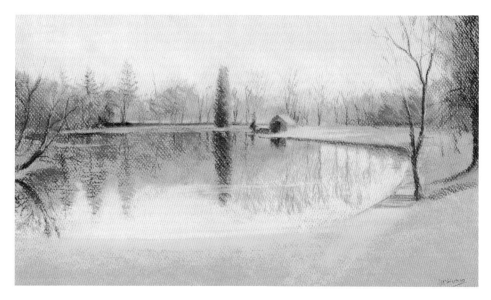

▲ Margaret Evans used a heavily grained paper for *Laich Loch, Gleneagles*,
which plays a very positive part in the impression of the gentle landscape
view. The texture has been carefully integrated with delicate treatment of
the pastel colour to unify the image.

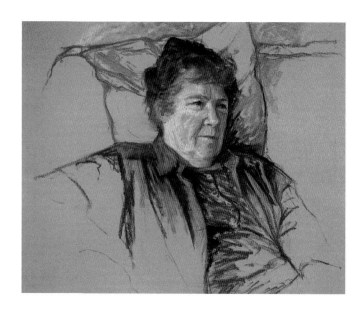

► For *Portrait of Celia*, Patrick
Cullen used fine sandpaper to
hold the pastel well and enable
crisp mark-making. It also gives a
slightly softened edge to the
pastel stroke. The fine tooth fills
quite quickly so that as colours are
overlaid it becomes more like a
painted surface.

Paper colours

Pastel paintings are usually carried out on coloured rather than white paper. The grainy texture of pastel allows the colour of the support to show through, so a coloured ground can be used to set an overall tonal value for the work – dark, medium or light – or to provide a colour bias in terms of warm (beige, buff or brown) or cool (grey, blue or green). The support tone can stand in for a dominant colour in the subject, such as blue or green for a landscape or buff or terra cotta for a townscape. Subtle hues are typically selected, but there are occasions when you might choose a strong colour to isolate the image and throw it into relief. A toned paper also makes it easier to judge the tones and intensities of your pastel colours.

Ingres and Mi-Teintes papers are both available in a wide range of colours. White papers, such as watercolour paper, should be toned before pastel work begins (see pages 68–69).

Neutral tints and bright colours

Neutral tints, such as beige, buff or grey, provide a mid-toned background that enables you to key your range of pastel tones and colours. These make good all-round choices. Some pastel artists choose a warm paper colour for a painting with a cool colour scheme because this provides an element of contrast, while others choose a support colour that tones in, such as a blue-grey for a seascape.

Colours that are bright or very densely saturated make a strong impact on the overall image, intensifying the hue and texture of the pastel marks. However, be aware that vivid supports may fight with the applied colours.

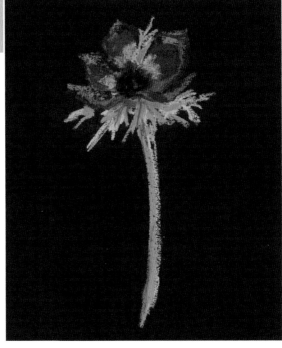

Effects of paper colour

These three examples illustrate how paper colour affects pastel colour.

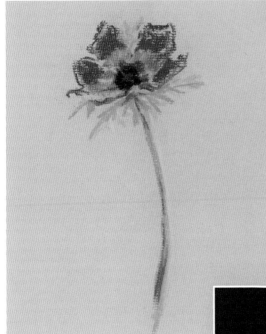

▲ The cool grey paper shows up the crimson of the poppy, making it look very vivid by contrast.

▲ The crimson has less impact on warm beige paper, but, interestingly, the warm background makes the red appear cooler.

▶ On black paper there is such a strong tonal contrast that a powerful, dramatic effect is achieved, so it is worth experimenting with dark papers.

Other equipment

One of the many attractions of pastel work is that you don't need much equipment. The basic requirements are pastels and paper. However, there are a few items that are useful to have to hand before you begin painting.

The first is something to support the paper. You don't need to go to the expense of buying a ready-made drawing board since most boards sold as building materials will suffice. If you work on a large scale you may want to buy an easel (see pages 48–49). After that, a few household items, erasers and a fixative may also be required.

Blending tools

A torchon is a roll of paper used to blend small areas. Cotton buds can also be used in the same way. For blending large areas, a household paintbrush or rag can be used.

Erasers

In the early stages of a pastel work any mistakes can be brushed off with a bristle brush. At the later stages, a kneaded eraser, or even white bread, can be used, while after many layers of colour have been built up it is best to scrape back with the blade of a craft knife.

Drawing board

Make sure your drawing board is wider on all sides than your paper, since if it is the same size it will cramp the composition and you are likely to tighten your style. The board can also act as a 'frame' for the picture, enabling you to judge the proportion and scale correctly. Any pits, bumps or cut lines on the board will be picked up by the pastels, so cushion the pastel paper with layers of acid-free paper attached to the board beneath it. This will give you a smooth, soft surface to work on.

Fixative

A spray fixative is not always required, depending on the artist's choice, but it can be used during the building up process, or once the pastel work is complete.

AN OUTDOOR KIT

When you are out and about it is essential that you have everything you need, so make a list of all the items you normally use, and check off each item as you gather them together. A possible list might include: pastels; pastel paper; drawing board; masking tape; easel; folding stool or chair; kneaded eraser; torchon or cotton buds; rags; fixative; tissue paper to protect work; plastic bag large enough to contain drawing board in case of rain; and suitable clothes, such as rainwear or sun hat and sun protection cream.

This all-in-one easel and storage tray is ideal for the outdoor painter. The box hooks onto the easel and can be detached and carried separately. The sliding lid keeps the pastels cushioned when carrying.

Masking tape

As well as for fastening sheets of paper to the drawing board, masking tape can be useful as a masking device when sharp edges are required.

Colour

Colour principles

When considering the effects of the colours you use it is helpful to know something about their individual properties and characteristics, and to understand the various terms used to describe them.

Primary, secondary and tertiary colours

Red, yellow and blue are known as the primary colours because they cannot be made by mixing together other colours. When any two primary colours are mixed together they form a secondary colour, so red and yellow make orange; red and blue make violet; and blue and yellow make green. Tertiary colours are a mix of all three primary colours or of one primary and one secondary colour (three colours in effect). Some of the tertiaries are the browns and greys, described as neutrals, but they can also be quite vivid – for example, blue-green.

Mixing cadmium yellow and crimson lake produces orange

Mixing lemon yellow and cerulean blue produces green

Mixing ultramarine and crimson lake produces violet

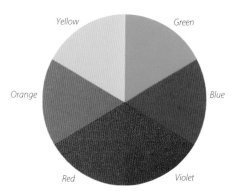

Yellow · Green · Orange · Blue · Red · Violet

The colour wheel

The colour wheel is a theoretical device that can be referred to when experimenting with colours and the ways in which they react with each other. It is basically a simplified version of the spectrum, bent into a circle. The wheel above is the standard colour wheel, while the one on the right shows actual pigment colours. You can see from this colour wheel that the colours next to each other tend to harmonize, and the ones on opposite sides of the wheel, called complementaries, are sharply contrasting. The colour wheel also helps you to get to know the relative temperatures of the colours you use (see Colour Terms, opposite). Notice that the cool colours are grouped on one side and the warm colours on the other.

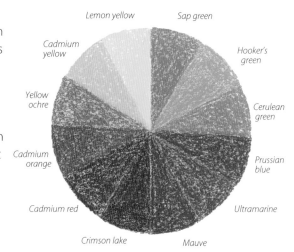

Lemon yellow · Sap green · Cadmium yellow · Hooker's green · Yellow ochre · Cerulean green · Cadmium orange · Prussian blue · Cadmium red · Ultramarine · Crimson lake · Mauve

Harmonious colours

Any two or three colours that lie next to each other on the colour wheel will appear harmonious, meaning that they work together well, with no jarring notes, since they share a common base colour. Examples of harmonious colour schemes might be blue, blue-green and blue-violet; or orange, red-orange and yellow-orange. The harmonious colours in this lovely example are pale and delicate, but they can equally well be dark and strong; the harmony comes from their close relationship on the colour wheel.

Complementary colours

Complementary colours fall opposite one another on the colour wheel. When placed side by side, the complementary colours are strengthened and enriched, they seem to intensify one another. However, the effect is completely different when they are overlaid or blended together, when they subdue or neutralize each other's intensity. This is useful to consider when you need to 'knock back' or dull a colour. In these examples the mixture is half and half, but you can use touches of complementary colour to grey a hue. If a green in the middle distance of a landscape looks too bright, for example, lay a very light veil of red over it.

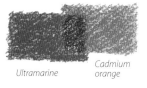

Ultramarine — Cadmium orange

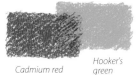

Cadmium red — Hooker's green

Cadmium yellow — Mauve

COLOUR TERMS

The following terms describe the specific properties that each colour possesses.

Hue is simply another word for colour and refers to the general colour of an object, as unaffected by light or shade. For example, when we say that grass is green we are referring to its overall hue, though the precise shade of green will appear lighter and warmer on a sunny day, and darker and cooler on a dull day or in shadow.

Tone, or **value**, refers to the relative lightness or darkness of a colour. Lemon yellow is light in tone, while indigo is dark in tone.

Intensity refers to how bright a colour is. Vivid, pure colours are strong in intensity; pale, greyed colours are weak in intensity.

Temperature All colours are described as being either warm or cool. On the colour wheel, red, orange and yellow are seen as being on the warm side, and green, blue and violet are on the cool side. Within these broad categories, however, each colour has varying degrees of warmth or coolness. For example, alizarin crimson, although a red, has a definite blue bias, so is described as a 'cool' red, while cadmium red has an orange bias and so is considered to be a 'warm' red.

Warm and cool colours

Although the cool colours are those with a blue content and the warm colours the reds, oranges and yellows, there are variations in temperature within each hue. Some blues are purplish and veer toward red, and are therefore warmer than those with a greenish tinge, such as turquoise. The crimson reds have a blue bias, and are cooler than the orangey reds, such as cadmium red, while a yellow that inclines toward orange, such as cadmium yellow, is warmer than the acid lemon yellow. It may sound complicated, but you will quickly learn to distinguish relative colour temperatures.

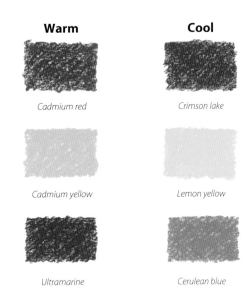

Warm | **Cool**

Cadmium red | *Crimson lake*

Cadmium yellow | *Lemon yellow*

Ultramarine | *Cerulean blue*

Creating depth

Warm and cool colours play vital roles in painting. Cool colours tend to recede, drawing themselves to the back of the picture, while warm colours advance to the front. Both can help create the illusion of depth.

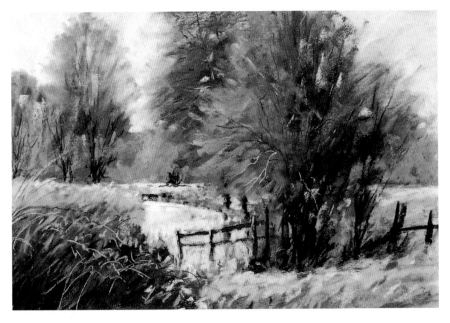

In *Frosty Morning* by Alan Oliver, the blues used for the distance push the background away, giving a strong sense of space. The blue is relatively warm, but still much cooler than the russets and red-browns of the foliage in the immediate foreground.

Colour relationships

No colour exists in isolation. Therefore, any colour can appear to be altered by the colours next to it. Colours can look warmer, cooler, brighter or more muted according to adjacent hues. A bright red or orange against a grey background will have more impact than if placed on yellow or another red; and a cool blue chosen for the distant hills of a landscape will not recede properly unless the foreground colours are more vivid and substantially warmer. These samples illustrate how colours look different according to those that surround them. The orange stands out well against the grey and black, but has less impact against the red. The cerulean blue looks vivid against the blue-grey, but less so against the orange-red and deeper blue. Bear the idea of colour relationships in mind as you work and you will quickly learn how to play one colour off against another and set up all kinds of exciting contrasts.

Orange on grey

Cerulean blue on blue-grey

Orange on poppy red

Cerulean blue on cadmium orange

Orange on black

Cerulean blue on cobalt blue

Neutrals

Pastel manufacturers produce a range of browns and greys, described as neutrals. However, it is worth remembering that they all have a definite colour bias and must be used with care, since they could look quite bright in a painting with a muted colour scheme.

Raw umber

Green-grey

Blue-grey

Purple-grey

Warm grey

Basic palette

Pastels are made in a huge range of colours, but you can start out with just 20 to 30 and add more as you need them. When choosing that first basic palette, a good rule of thumb is that you will need at least two versions, a cool and a warm, of each of the primary hues, plus three or four greens and browns, two different greys, a white and a black. An orange and one or two violets could also be included. Most pastel manufacturers produce boxed starter sets of between 12 and 20 colours. These are adequate for early experiments, and you can buy more colours as single sticks once you begin to work seriously.

A recommended starter palette

The 24 colours shown here provide a range of values suitable for most subjects. Additional colours can be produced by mixing and variations of tone made by using light or heavy pressure, or by adding white.

1	Ultramarine tint 6	13	Lemon yellow tint 6
2	Ultramarine tint 1	14	Olive green tint 8
3	Prussian blue tint 3	15	Hooker's green tint 3
4	Cerulean blue tint 4	16	Hooker's green tint 1
5	Purple tint 6	17	Sap green tint 5
6	Mauve tint 2	18	Lizard green tint 3
7	Crimson lake tint 6	19	Green-grey tint 1
8	Cadmium red tint 6	20	Blue-grey tint 4
9	Cadmium orange tint 4	21	Cool grey tint 4
10	Yellow ochre tint 6	22	Burnt umber tint 8
11	Yellow ochre tint 2	23	Raw umber tint 6
12	Cadmium yellow tint 4	24	Burnt sienna tint 4

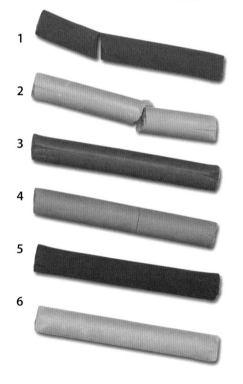

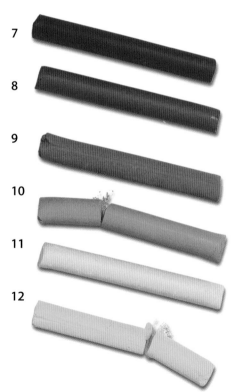

MAKING A TINT CHART

A useful and effective way to get to know your pastel colours is to make a tint chart. This is simply a sheet of paper on which you keep a visual record of all your pastel colours. The paper labels on pastel sticks do tend to come off or disintegrate in use and when this happens you have no way of knowing the name or exact tint number of the colour, making it extremely difficult to buy a new one. So, to keep a record, each time you buy a new pastel, fill in a square of that colour on the chart and write in its name and number.

Coal Cerulean No. 4

Ultramarine Blue No. 1

Lemon Yellow No. 6

Mauve No. 2

Hooker's Green No. 3

Blue Gray No. 4

Hooker's Green No. 1

Prussian Blue No. 3

Green Gray No. 1

Olive Green No. 8

13
14
15
16
17
18
19
20
21
22
23
24

Adding to a basic palette

As you grow proficient at pastel work you will probably want to add new colours to your basic palette, based on the subjects you most like to paint.

Landscapes

The predominant colour in most landscapes is green, and even if you have five greens and a green-grey in your basic palette, you will probably need more. A larger selection of blues will give you more flexibility over skies, and some additional browns and greys will be useful for trees, cloud colours and distant features.

Flowers

Many of the vivid oranges, brilliant pinks and purples of nature's flowers are impossible to achieve by mixing other colours. Therefore, you may find the following extra colours useful additions to your palette.

Buildings

Compared to flowers, buildings are muted in colour, so you will want to extend your range of neutral browns and greys. However, brickwork and tiled roofs can be colourful, particularly when the sun is shining on them, so have some extra red-browns, pinks and yellows to hand as well.

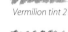
Vermilion tint 6

Vermilion tint 2

Viridian tint 6

Grass green tint 1

Rose madder tint 6

Rose madder tint 2

Lizard green tint 7

Terre verte tint 5

Blue-grey tint 2

Blue-grey tint 0

Pansy violet tint 8

Pansy violet tint 3

Cobalt blue tint 4

Cobalt blue tint 2

Cool grey tint 6

Indigo tint 1

Purple tint 4

Purple tint 8

Cerulean blue tint 0

Indigo tint 6

Red-grey tint 4

Red-grey tint 2

Indigo tint 3

Mauve tint 3

Indian red tint 6

Indian red tint 4

Lemon yellow tint 2

Cadmium yellow tint 6

Burnt umber tint 4

Burnt umber tint 1

Yellow-green tint 3

Cadmium orange tint 6

Cadmium red tint 1

Cadmium orange tint 1

Burnt sienna tint 0

Green-grey tint 1

Cadmium orange
tint 4

Yellow ochre tint 4

Raw sienna tint 6

Raw sienna tint 1

Naples yellow tint 2

Blue-grey tint 2

Colour mixes

Pastels are different from every other painting medium in that the process of mixing colours takes place on the paper itself, not on a palette. Because pastels can't be premixed as paints can, manufacturers produce an especially wide range of primary, secondary and tertiary colours. Even so, you are bound to want to modify existing colours. For example, no pastel box, however extensive, contains enough greens to match the diversity of nature, so you may find you need to add yellow, blue or even its complementary red, to alter an existing green. And once you become familiar with your colours, you may discover that you can make a better green yourself by mixing yellow and blue.

The selection of soft pastel colour mixes featured over the following pages will give you an idea of what can be achieved by overlaying two pastel colours and encourage you to try your own mixes based on the subjects you like to paint. Each colour bar is divided into three sections. The section farthest left indicates the result of adding the smallest amount of the colour appearing above the colour bar, with more of the colour added in the middle section, and the most in the section farthest right.

Reds

Lake rose 270 Sennelier

Crimson lake tint 3

Cadmium red tint 4

Scarlet lake 303 Sennelier

Lake rose 270 Sennelier

Vermilion 080 Sennelier

Lake brown 269 Sennelier

Ruby red 670 Sennelier

Yellows

Lemon yellow 600 Sennelier

Yellow ochre 115 Sennelier

Yellow ochre 117 Sennelier

Naples yellow 102 Sennelier

Lemon yellow 600 Sennelier

Cadmium yellow tint 4

Cadmium yellow light 297 Sennelier

Gamboge 368 Sennelier

Blues

Cerulean blue 261 Sennelier

Ultramarine 388 Sennelier

Prussian blue 463 Sennelier

Cerulean blue 257 Sennelier

Cerulean blue 261 Sennelier

Sapphire blue 620 Sennelier

Cobalt blue 353 Sennelier

Cobalt blue tint 2

NOTE
Some of the distinctive colours that have been used on these pages are specific to certain manufacturers. Therefore, where a manufacturer does not use a standard tint number from one to ten, the manufacturer and brand number of the colour used is specified.

Violets

Pastel manufacturers produce a range of violet shades, which can of course be modified with other pastel colours. Alternatively, mix blue and red tints to produce your own violets and mauves.

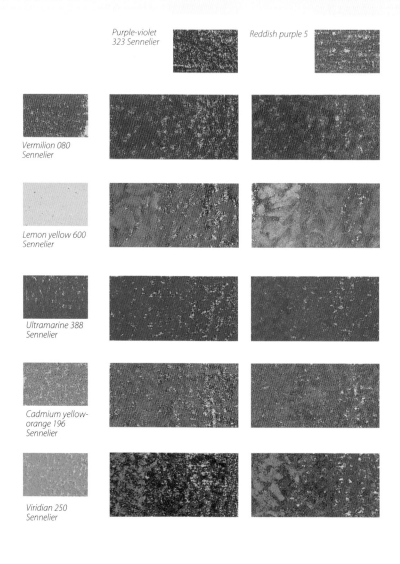

Purple-violet
323 Sennelier

Reddish purple 5

Vermilion 080
Sennelier

Lemon yellow 600
Sennelier

Ultramarine 388
Sennelier

Cadmium yellow-
orange 196
Sennelier

Viridian 250
Sennelier

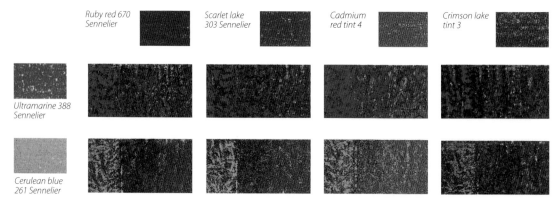

Ruby red 670
Sennelier

Scarlet lake
303 Sennelier

Cadmium
red tint 4

Crimson lake
tint 3

Ultramarine 388
Sennelier

Cerulean blue
261 Sennelier

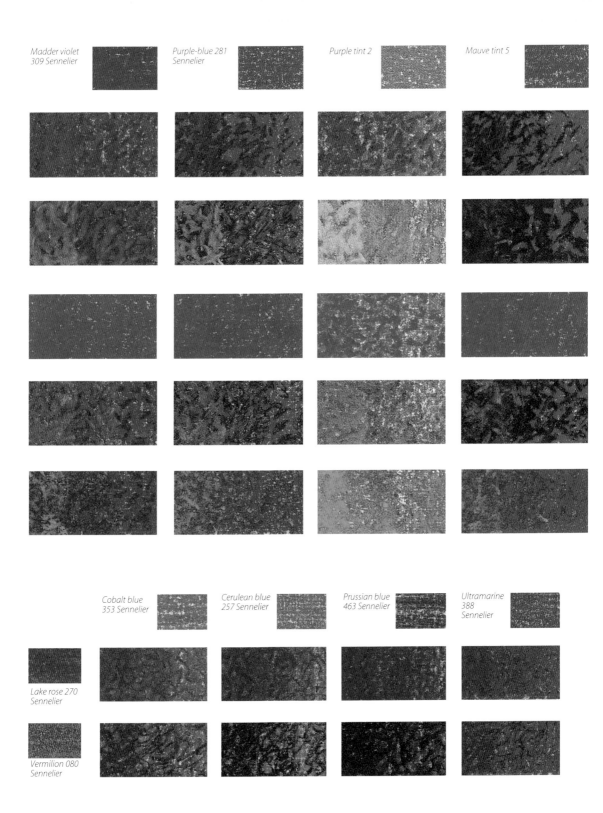

Madder violet
309 Sennelier

Purple-blue 281
Sennelier

Purple tint 2

Mauve tint 5

Cobalt blue
353 Sennelier

Cerulean blue
257 Sennelier

Prussian blue
463 Sennelier

Ultramarine
388
Sennelier

Lake rose 270
Sennelier

Vermilion 080
Sennelier

Oranges

As with all pastel colours, manufacturers produce a variety of orange shades that can be modified with other colours. Alternatively, mix yellow and red tints to produce your own variations.

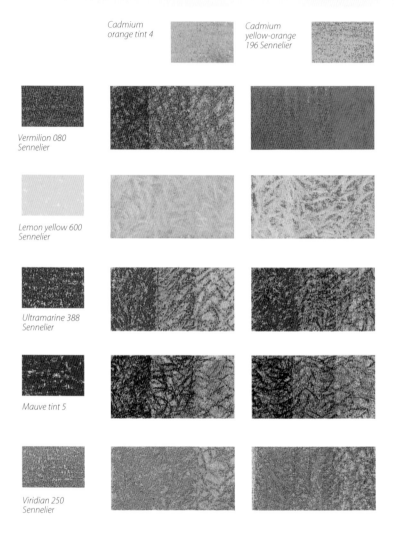

Cadmium orange tint 4

Cadmium yellow-orange 196 Sennelier

Vermilion 080 Sennelier

Lemon yellow 600 Sennelier

Ultramarine 388 Sennelier

Mauve tint 5

Viridian 250 Sennelier

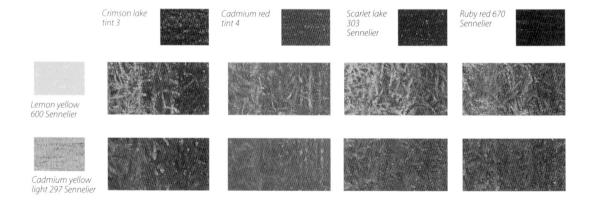

Crimson lake tint 3

Cadmium red tint 4

Scarlet lake 303 Sennelier

Ruby red 670 Sennelier

Lemon yellow 600 Sennelier

Cadmium yellow light 297 Sennelier

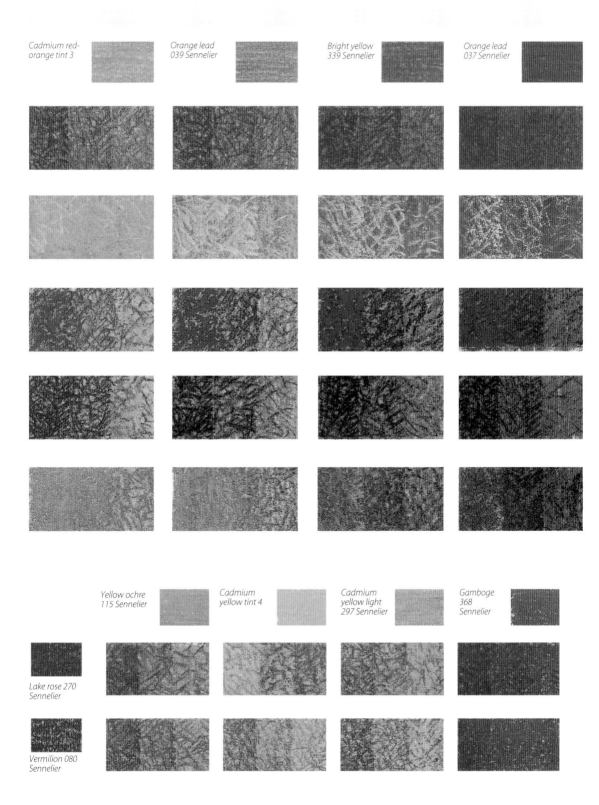

Cadmium red-orange tint 3

Orange lead 039 Sennelier

Bright yellow 339 Sennelier

Orange lead 037 Sennelier

Yellow ochre 115 Sennelier

Cadmium yellow tint 4

Cadmium yellow light 297 Sennelier

Gamboge 368 Sennelier

Lake rose 270 Sennelier

Vermilion 080 Sennelier

Greens

Greens can be difficult colours to mix, because nature provides such a large variety, ranging from rich olives through to subtle blue-greens and brilliant, almost yellow, greens. Pastel manufacturers produce a variety of green shades that can be modified with other colours. Alternatively, mix yellow and blue tints to produce some of your own.

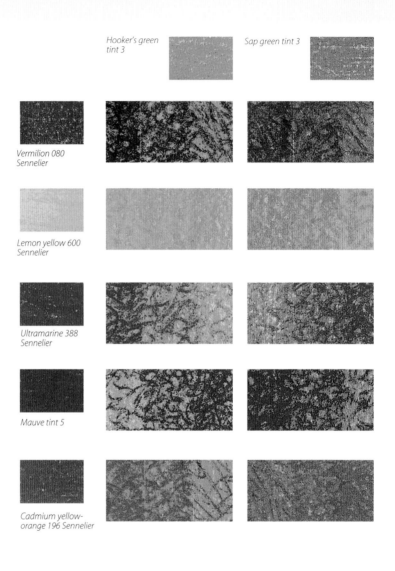

Hooker's green tint 3

Sap green tint 3

Vermilion 080 Sennelier

Lemon yellow 600 Sennelier

Ultramarine 388 Sennelier

Mauve tint 5

Cadmium yellow-orange 196 Sennelier

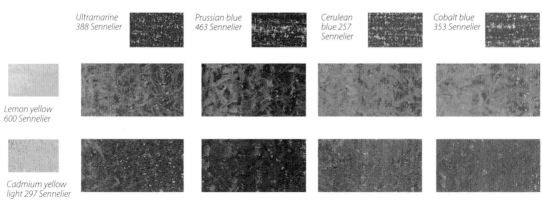

Ultramarine 388 Sennelier

Prussian blue 463 Sennelier

Cerulean blue 257 Sennelier

Cobalt blue 353 Sennelier

Lemon yellow 600 Sennelier

Cadmium yellow light 297 Sennelier

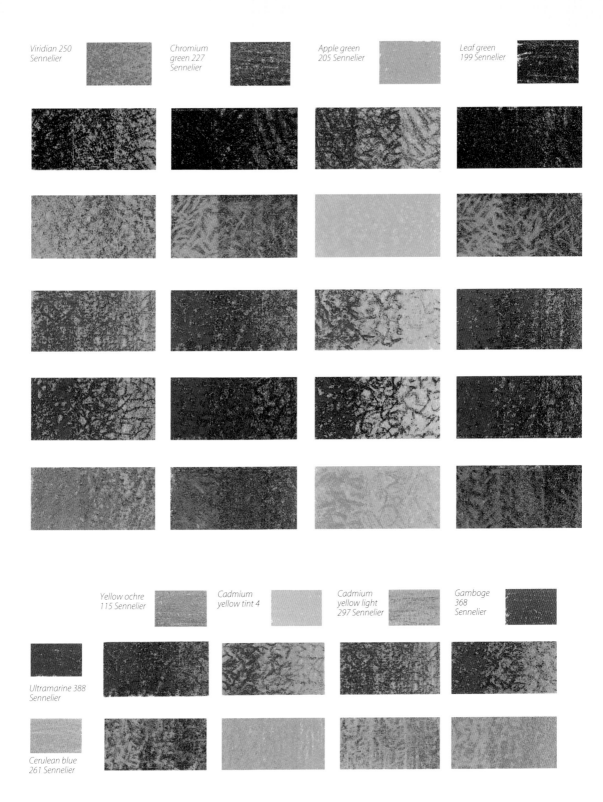

Viridian 250 Sennelier

Chromium green 227 Sennelier

Apple green 205 Sennelier

Leaf green 199 Sennelier

Yellow ochre 115 Sennelier

Cadmium yellow tint 4

Cadmium yellow light 297 Sennelier

Gamboge 368 Sennelier

Ultramarine 388 Sennelier

Cerulean blue 261 Sennelier

Browns, greys and blacks

Like all pastel colours, the browns, greys and blacks are
affected by the colours placed next to them and that overlay
them. The following charts will give you an idea of how you
can combine these colours to suit your needs.

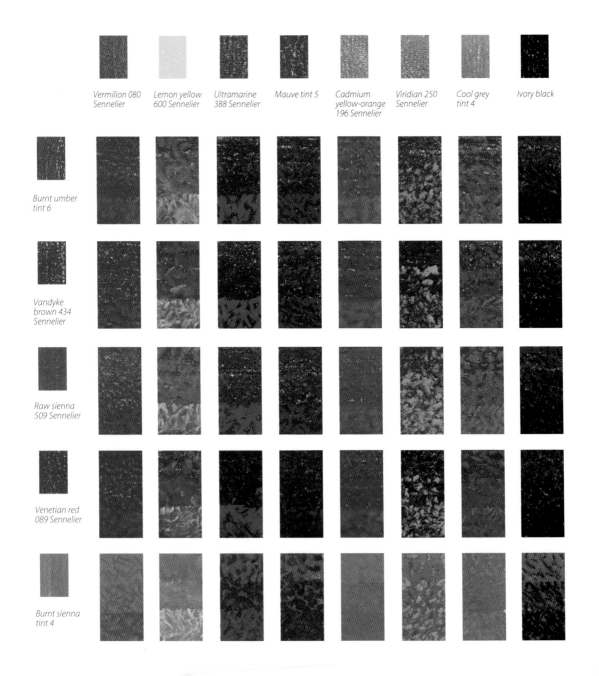

	Vermilion 080 Sennelier	Lemon yellow 600 Sennelier	Ultramarine 388 Sennelier	Mauve tint 5	Cadmium yellow-orange 196 Sennelier	Viridian 250 Sennelier	Cool grey tint 4	Ivory black
Burnt umber tint 6								
Vandyke brown 434 Sennelier								
Raw sienna 509 Sennelier								
Venetian red 089 Sennelier								
Burnt sienna tint 4								

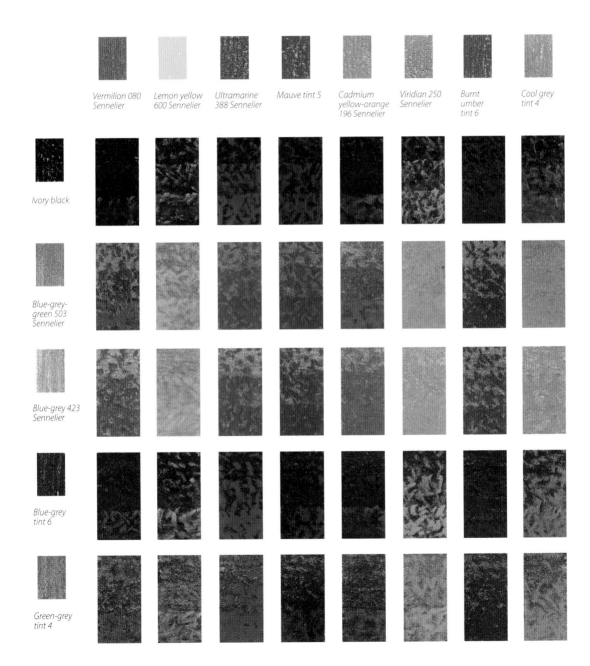

Vermilion 080
Sennelier

Lemon yellow
600 Sennelier

Ultramarine
388 Sennelier

Mauve tint 5

Cadmium
yellow-orange
196 Sennelier

Viridian 250
Sennelier

Burnt
umber
tint 6

Cool grey
tint 4

Ivory black

Blue-grey-
green 503
Sennelier

Blue-grey 423
Sennelier

Blue-grey
tint 6

Green-grey
tint 4

Using greens

In this largely linear painting, viridian has been used as a base, with other greens laid on top. In many areas these have been overlaid with darker, cooler or brighter colours to increase contrasts and heighten the dramatic atmosphere.

▶ **1** The main colour used here is viridian. The shadowed side of the tree has been overlaid with ultramarine and black, while the sunlit side has been lightened with pale chrome green and lemon yellow. An outline of madder lake provides a lively edge that separates one dark tree from the next, as well as suggesting the heat of the day.

◀**2** The trees on the left use permanent green and Hooker's green, overlaid with ultramarine, deep turquoise, pale cream and pink. The trunks and branches are combinations of permanent rose and pale chrome green, providing a pale, warm contrast to the dark, cool masses of foliage.

◀**3** Tree shadows of crimson, burnt sienna and ultramarine provide warm horizontal counterpoints for the main verticals of the composition.

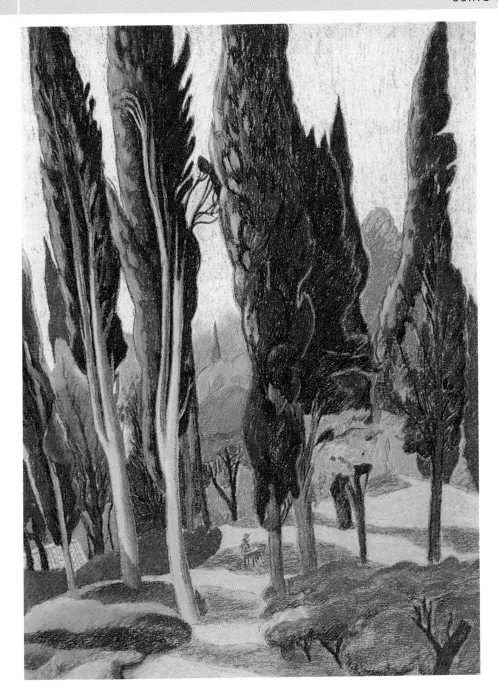

Rosalind Cuthbert *Cypresses, Fiesole*
The naturally elegant, elongated forms of the cypress trees have been stylized into distinctive, solid shapes using dense shading. The paper is greenish brown, sufficiently neutral to appear pinkish through the greens and greenish through the pinks of earth and shadows. This imbues the applied colours with a gentle liveliness.

Using browns and greys

The palette for this picture is very simple, consisting mainly of grey, ochre, white and umber, although other colours have been smudged in to further enliven the surface.

▲ **1** Umber, burnt sienna and grey are used to describe the bronze skin against the light.

▲ **2** Empty areas of the composition effectively heighten the effect of movement by contrast. However, nowhere is the colour completely flat; ochre and pale pink hatched together suggest gently vibrating light and air.

▲ **3** Ultramarine, Prussian blue and crimson partly smudged together form the dancer's leotard. The white outline suggests speed as well as emphasizing the backlighting.

▶ **4** Pink and mauve create soft shadows, warming up an otherwise cool colour scheme.

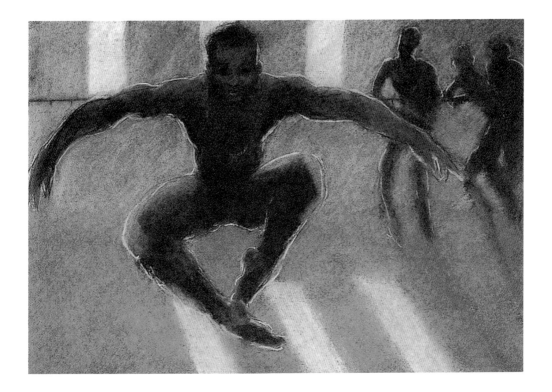

Carole Katchen *Ronnie in the Air*
This pastel has been done on a cool grey paper,
with the colours broadly hatched on and lightly
blended with a finger, and white highlights
added later. The effect is light and energetic in
keeping with the subject.

Mixing skin tones

We tend to think of skin as basically pink, cream or brown, when in fact skin tones vary enormously. The lighting conditions also make a great difference; for instance, in shadowy areas pale skins can look greenish or mauve, while dark skins could seem greenish-brown or purple-black. Pitching the tonal value correctly is at least as important as finding the 'right' colour, and you may find yourself using quite surprising colours to indicate nuances of light or shade.

There are many different formulas for painting flesh, and artists will invent their own palettes based on observation, preference and style. The following charts can be used as a guide as you begin depicting skin, and, of course, can be adapted to your needs.

Very dark complexions

Burnt sienna over ultramarine *Orange over black* *Burnt sienna over black*

Shadows *Highlights*

Burnt sienna over ultramarine over black *Viridian over cadmium red over black* *White over cadmium orange over purple* *White over cerulean blue over burnt sienna*

Mid-brown complexions

Yellow ochre over burnt sienna *Cadmium orange over burnt sienna* *Grey over burnt sienna*

Shadows *Highlights*

Burnt sienna over cobalt blue *Cadmium orange over ultramarine* *White over cerulean blue over yellow ochre* *White over cerulean blue over crimson lake*

Olive complexions

Grey over cadmium yellow over burnt sienna

White over cadmium orange over purple

White over cadmium orange over cerulean blue

Shadows *Highlights*

Cobalt blue over cadmium red over yellow ochre

Cadmium orange over purple

White over yellow ochre

White over yellow ochre over cerulean blue

Pale complexions

White over yellow ochre

White over crimson lake over cadmium orange

White over cadmium orange over cerulean blue

Shadows *Highlights*

White over crimson lake over cerulean blue

White over cadmium yellow over purple

White over cerulean blue

White over cadmium yellow

Using skin tones

When painting a portrait it is a good idea to choose a tinted paper that will complement the colouring of the sitter. Here a green-grey paper was chosen because it blends well with the sitter's hair, skin colour and the blue shawl. A greenish-grey that blends with the paper has been used for the shadow areas.

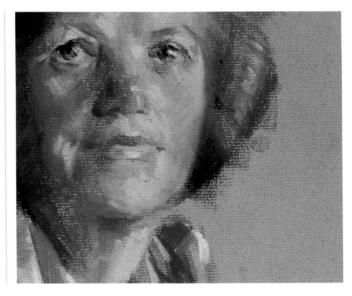

▲ **1** To model the face and give it liveliness, the artist has used an extensive range of flesh-coloured tones – light orange, Naples yellow, grey-green and pink – and left them unblended so that the colour actually models the shape of the face.

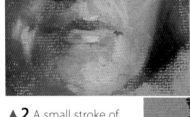

▲ **2** A small stroke of white across the lower lip pulls the mouth forward.

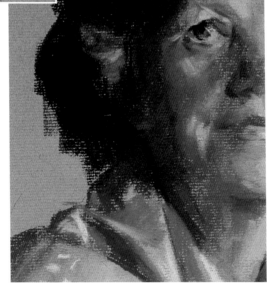

◀ **3** The greenish-grey of the shadows blends in with the green-grey paper and helps to pull the lighter tones of the face forward.

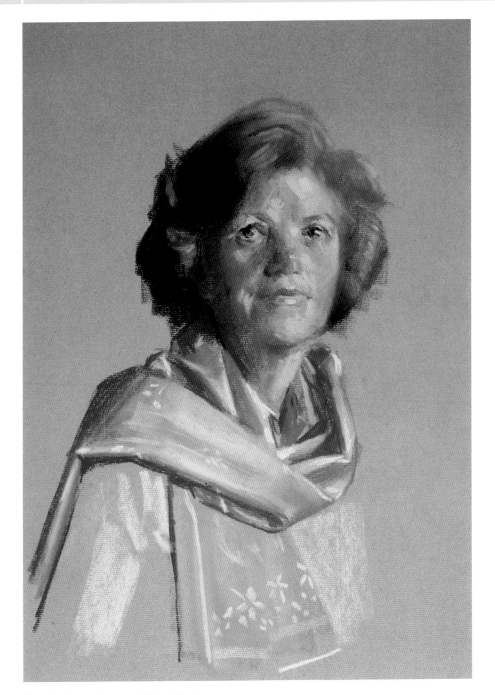

Ken Jackson *Portrait of Mrs. Clark*
In this portrait the edges of the face are very soft, although considerable tonal contrast has been used, and no hard contours appear anywhere. Instead, the whole face has been built up through colour.

Basic Techniques

Working practice

As soon as you start to use pastels you will find out just how messy they can be. Coloured dust falls onto any nearby surface, your hands become covered with it and perfect new pastel sticks acquire a muddy coating from jostling with other colours on the work table. In order to minimize mess and ensure a comfortable painting experience, a few basic steps can be taken each time you begin work.

Working position

A good way to work is with the paper on a board at a slight tilt, so that loose powder falls away from the surface. This may be on a table, with the board stacked from the back, or at an easel. This position also allows you to step back and assess your work from a distance; it is difficult to judge it properly if you are too close. Pastel dust flies around if you try to sweep it, so it can be a good idea to put an old sheet, drop cloth or plastic sheet under the table or easel. This can be gently shaken outside when you have finished working.

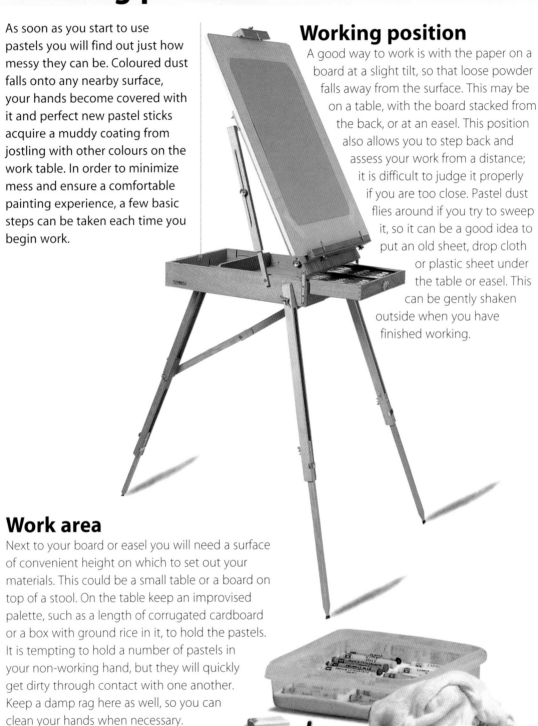

Work area

Next to your board or easel you will need a surface of convenient height on which to set out your materials. This could be a small table or a board on top of a stool. On the table keep an improvised palette, such as a length of corrugated cardboard or a box with ground rice in it, to hold the pastels. It is tempting to hold a number of pastels in your non-working hand, but they will quickly get dirty through contact with one another. Keep a damp rag here as well, so you can clean your hands when necessary.

Avoid smearing

It is only too easy to smear areas of a painting with your hand as you work. To avoid this, cover the completed area with a sheet of paper and rest your hand on that while working on the next area. If possible, think about working methodically: from left to right if you are right-handed and vice versa if you are left-handed, and from the top down.

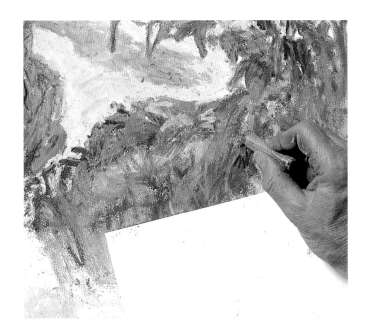

Using a mahlstick

A mahlstick keeps your hand away from the paper. You can make your own by padding one end of a piece of cane or dowel.

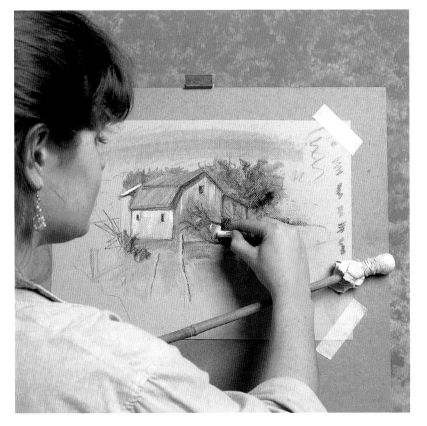

Side strokes

The side stroke is one of the most expressive strokes in pastel painting and numerous effects can be achieved by varying the pressure on the pastel and using different movements of the wrist. Heavy pressure forces more pastel particles into the tooth of the paper to create an almost solid, dense quality. When applied lightly, the tooth of the paper shows through the colour, creating a random, broken texture.

Side strokes are excellent for covering large areas in a painting. On rough paper the grainy effect can be used to suggest specific textures, such as tree bark or woven fabric. However, this technique works best when used judiciously and as a contrast to linear work.

Even strokes

To lay the colour evenly, draw the side of a pastel stick firmly across the paper surface. The density of colour depends on the pressure you apply and quality of the paper grain.

Graduated colour

You can obtain graded colour effects by lightening the pressure as you extend the stroke.

Overlaying

Side strokes can be overlaid in different directions to build up colour density. However, take care not to overlay the strokes too heavily, or in too many layers, because the colours will become overmixed and degraded.

Paper texture

The texture of the paper is particularly important when working with pastels. A heavily toothed surface will not completely fill with colour even if you apply strong pressure.

◄ Light strokes made on a rough paper (top) will give a broken texture, while the same strokes on a smoother paper (below), although still grainy, fill more of the tooth.

Linear strokes

Linear strokes are made with the tip or short edge of the pastel and can be infinitely varied. Much can be learned by experimenting with linear strokes, applying varying degrees of pressure and holding the stick in different ways. The range of effects that can be produced can be exploited for describing space, distance, volume and contour, and used to build blends of tones and colours.

Fine lines

Using the corner of the tip of the pastel you can produce precise, sharp lines.

Thick lines

A free stroke with the tip of the pastel produces a lightweight, but thick, soft line.

Varying weights

By varying pressure and turning the pastel you can produce fine lines that swell into grainy trails, or broad strokes that taper off narrowly.

Paper texture

◀ Linear strokes on rough paper produce a splattered, irregular line because the tooth of the paper breaks up the colour.

▶ The same strokes on smooth paper give a denser, smoother line, particularly if the pastel is pushed into the surface.

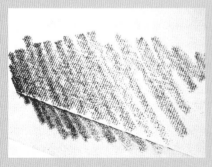

SHADING

Shading is a way of applying continuous tone or colour. The technique is a controlled back-and-forth motion travelling gradually across the working surface so that the strokes shade into one another. The effect is one of evenly massed colour rather than individual marks and varying the pressure allows you to develop tonal gradations.

Conventionally, the effectiveness of shading depends on working the strokes consistently in the same direction, which provides an even surface finish.

Tutorial **Using basic strokes**

This painting, using soft pastels on sandpaper, illustrates just what can be achieved using simple side and linear strokes. Working from a general lay-in that determined the composition and spacing, the artist moves to the broader areas like the fields, which he blocks in using the side of the pastel. Once the solid forms have been established, he picks out sharp details, such as branches, shadows and roofs, using a pointed scrap of pastel.

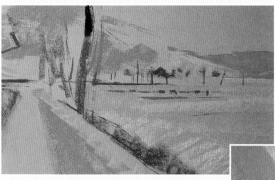

1 When starting to lay in the composition the artist uses thin lines to determine spacing – for example, on the horizon and surface of the road. Vertical strokes, applied quite heavily in parts, help him to block in the tree shapes and mass of the hill.

2 The artist goes over the blocked-in blue shadows of the trees using the side of the stick.

3 Using the side of the pastel allows the artist to spread the green over a fairly large area. He does not use uniform pressure, and in parts the blocking is quite light, so that other colours can be added later.

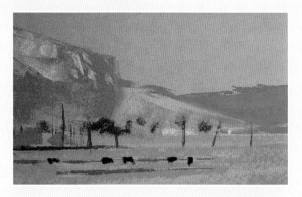

4 The artist has chosen quite solid strokes for the distant hills, but he manages to stop the picture looking flat by employing lively strokes of light blue on the cliff face. The picture is built up using the basic strokes, leaving some less worked than others.

5 Now to the details. The artist uses a small but sharp scrap of cream pastel to highlight the tree trunks and side of the house.

6 Tiny dots of white are used to pick out the corn in the foreground, providing an effective contrast to the blended green of the field.

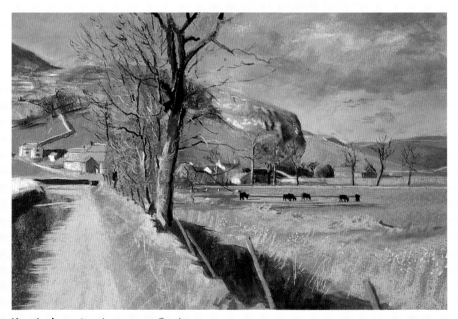

Ken Jackson *Landscape near Castleton*
The fine lines used to suggest the branches and shapes of the buildings help to keep the detail separate from the broader masses of road, hill and sky. The pastels have been used thickly in the foreground, which contrasts with the lighter touch used in the corn, and also helps to lead the eye back to the distant details. The use of white highlighting on the wall, branches and road stops the picture looking too bland and provides a strong impression of light effects.

Gestural drawing

The essence of this technique is to use rapid and uninhibited movements of the pastel to capture the immediate impression of a subject. You can often see this in drawings of people and animals in motion – one line is drawn over another in free, fast movements of the hand and wrist. The effect gives the impression of movement and the image is created through a network of lines rather than one line alone.

Aim to develop a free connection with what you observe and the way you translate it to paper, letting the motion of your hand and arm echo the rhythms of the shape and contours. The spontaneity of the approach is lost if you become concerned with individual details.

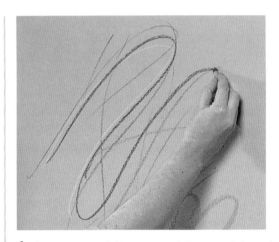

1 The essence of this approach is to work broad and free, so you should not be too close to your picture. Working with the paper taped to a wall or at an easel is preferable so that you can hold the pastel at arm's length and work from the elbow. To practise this style of working, make bold, sweeping strokes over the surface.

2 Now try to vary the strokes, using the side of a short length of pastel to add broad, straight lines.

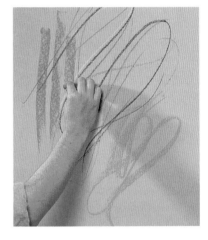

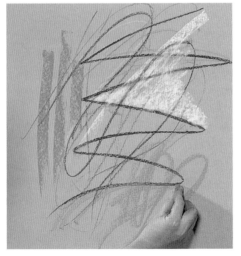

3 Continue to build up the effect, filling some areas and leaving others. Don't think too hard about what you are doing, but aim to get a feel for working from the elbow.

Describing movement

▶ Rapidly drawn and varied lines are ideal for describing movement. In this horse sketch, light side strokes, which describe the rounded forms, are overlaid with line strokes following the direction of movement.

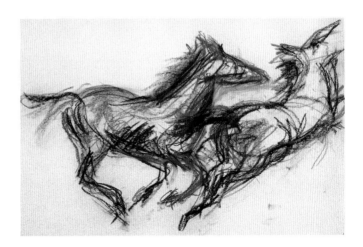

Landscape

◀ Movement within landscapes can also be tackled using gestural strokes. Here a powerful impression is made using almost no colour – just the colour of the paper plus black and white.

Shape and form

▶ In Kay Gallwey's *Ballet Dancer*, active treatment of every area of the image enhances the impression of shape and form. Directional marks are used to indicate the structure and detail of the background location, to describe the textures of the dancer's dress and hair, and to suggest her movements. Visual contrasts are created between some strokes that are fragile or harshly linear and others that are broad and richly grained.

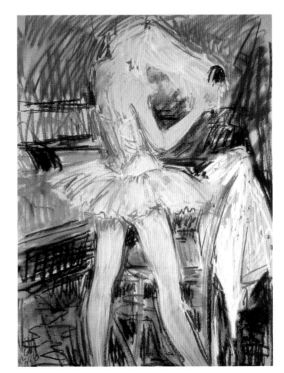

Blending

Blending involves rubbing one colour into another and into the paper so that lines are softened and colours and tones merge. Much of pastel's impact comes from the grainy, rough textures the medium creates and the loose networks of individual pastel strokes. However, the subtleties of blended colours and smooth gradations of hues and tones are vital elements in rendering specific materials and surface qualities – for example, uniform, reflective surfaces such as metal and glass, or soft fabrics – as well as atmospheric impressions. Blended colours also provide visual contrast when integrated with loose pastel strokes.

For large areas, such as skies, it is best to lay on the colour with the broad side of the pastel and blend with a rag, paintbrush or the flat of the hand. The latter is often preferred because the small amount of oil in your skin mixes with the pastel and makes it adhere to the paper so that it is more easily pushed into the surface. When it comes to small areas that you need to control precisely, blending with a finger, cotton bud or torchon is preferable.

Hand blending

1 Place thick bands of colour one above the other, then soften the boundaries between colours with the side of your hand.

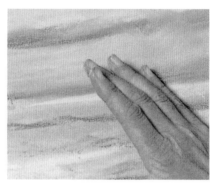

2 Introduce more colours as you progress, applying them lightly with the top or side of the pastel stick.

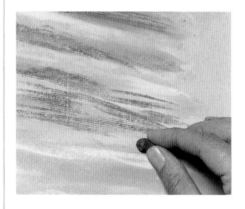

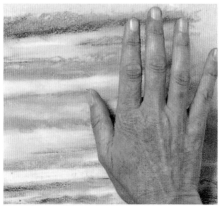

3 Rub with your fingers, thumb or whole hand to soften the boundaries between colours and blend the strokes. Hand blending produces less dust than blending with a rag or brush.

Blending with a rag

1 Apply the colours lightly, without pressing the pigment into the paper. Brush over the colours with a rag to remove some of the colour.

2 Continue adding pastel and blending until you achieve the desired depth of colour. To enhance shapes, blend each one separately, drawing the rag along the shape rather than across it.

Blending with a paintbrush

1 A paintbrush is good for conveying a diffused effect over an extensive area. Lay broad side strokes of pastel then brush along them – not across – to blend. The brush will remove a good deal of colour, leaving the strokes blurred but still visible.

2 For more definite areas, apply fine lines and brush gently over them to soften the edges.

Fine blending with a torchon

This special tool for blending pastels is a tight roll of paper shaped like a pencil. Gently rub the pastel area with the tip or side of the torchon to soften and blend the colours. To obtain a clean point on the torchon simply unwind some of the paper from the tip.

MAKING A TORCHON

To make your own torchon, take a cocktail stick and a small piece of damp paper towel. Roll the paper around the stick without letting it protrude too far beyond the points of the stick. The paper will shrink as it dries to form a tight covering, without the need for further adhesive.

Fine blending with a finger

Apply the pastel colours first and rub with a finger to create soft edges and mix the colours together.

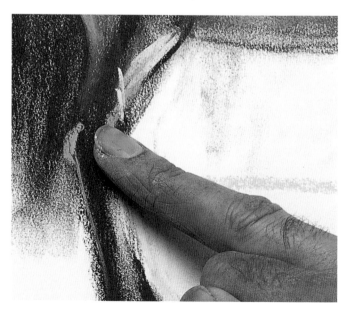

Fine blending with a cotton bud

Lay down your first colours and merge them with fingers first, reserving the cotton bud for precise blending in the later stages. After applying darker areas, use the cotton bud in a drawing action to soften the transition from light to dark and to define the edges.

Blending oil pastel

Oil pastel cannot be blended with fingers or implements, but needs to be dissolved with white spirit or turpentine. Lay the colours as usual. Dip a rag or brush in white spirit and wipe it over the area to be blended.

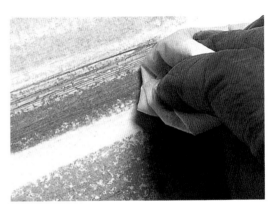

COMBINING BLENDING METHODS

Lois Gold's *Beach Grasses* uses a number of the blending methods discussed above. The rich colours of the sky were achieved by applying one colour over another and blending them with sweeping motions of the hand. Smaller areas were blended with the fingertips and the grasses were blended using a torchon.

Surface mixing

Unlike paints, pastel colours cannot be mixed in a palette before being applied to paper, instead the colours are mixed on the paper itself. Even if you have an extensive range of pastel colours, some surface mixing is nearly always necessary.

Surface mixing simply involves laying one colour on top of another, and different effects can be achieved according to whether you blend the colours or leave them unblended. Blending will achieve a thorough, homogeneous mix, whereas an unblended mix will give a more broken impression of the resulting colour. Bear in mind, however, that too much blending can muddy the colours.

Blended mix

Here the side strokes of yellow over blue have been blended to produce a smooth application of a lively green, which is more visually exciting than a ready-made green.

Unblended mix

Line strokes of yellow over blue have been left unblended. The colours do mix thoroughly but give the impression of green when viewed from a distance.

Subtle mixes

To achieve soft gradations of colour and subtle mixes, lay down two colours, one over the other, and rub them together with a finger or torchon.

Graduating colour

To depict colours that merge gradually into one another, lay bands of colour using side strokes and blend together the edges where the colours meet. This series shows the very subtle effects that can be created by blending one colour into another.

Broken colour

Broken colour is a way of mixing colours without blending. Each area is built up with short strokes of different colours that mix visually from a distance. This is also called optical mixing and its charm lies in the shimmering quality of each area of colour. Broken-colour effects are excellent for foliage, grass, skies or any subject where the quality of light on a surface needs to be expressed.

As with surface mixing, overmixing will result in a muddy effect, so think carefully about the range and number of individual colours you want to use. It is usually a good idea to keep the colours close in tone – a juxtaposition of lights and darks will be jumpy and incoherent.

Effects of light

Broken-colour effects are often used for landscapes and are particularly effective for snow scenes and skies because they convey the shimmering effect of reflected light much better than a flat area of colour does. In *Toward Cambridge, Winter*, by Geoff Masters, the snow is composed of many short strokes of blue interspersed with white, pale orange and grey-green, while the trees are built up with deeper colours in the same way.

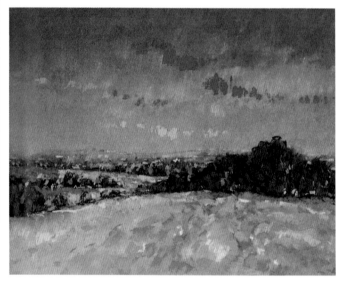

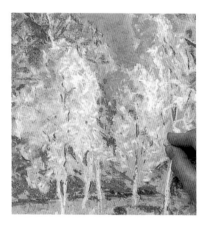

Broken-colour technique

Use short lengths of pastel to build up the whole surface with varied small strokes in a variety of colours.

Patterns

In *Morning in September*, Simie Maryles has used broken colour to emphasize the pattern element in the scene. Notice how she has woven red into the greens of the tree.

Stippling

This broken-colour technique uses dot patterns rather than more naturalistic short strokes. When painting *The Alhambra*, Susan Alcantarilla used a form of stippling to illustrate the play of dappled light on the interior of the palace. She has varied the size of the dots so the work has a delightful sparkle and is vibrantly alive.

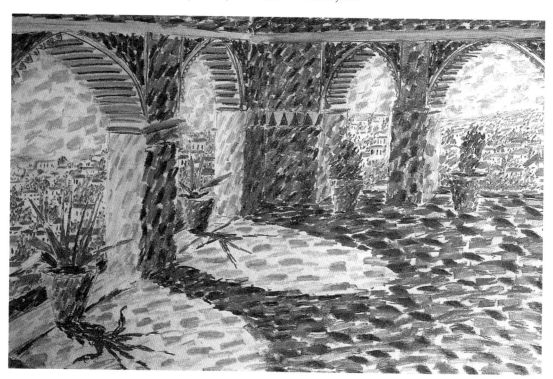

OIL PASTELS

Oil pastel has a moist quality, which means that overlaid broken-colour marks produce actual colour blends as well as the effect of optical mixing.

Hatching and crosshatching

The hatching and crosshatching methods of creating tonal values are often associated with monochrome drawing techniques, but they can also be usefully applied to colour work. With hatching, separate and roughly parallel strokes are laid next to one another, while with crosshatching a further set of strokes crosses the first at or near to a right angle. From a distance the lines merge to give an impression of continuous tone or colour, while the linear texture contributes a lively surface that can provide a good contrast to blended colour. By interweaving different colours you can achieve particularly vibrant colour mixes. Each hue retains its own identity, but blends partially with adjacent colours in the viewer's eye.

Variations of tone

Hatched and crosshatched lines need not be uniform in thickness. Variations of tone and texture can be obtained by varying the quality of the line between thick and thin, and the widths of the spaces between the lines.

Varying direction

Hatched lines need not be straight or one-directional. Overlaid curves build up a loose, informal kind of crosshatching.

Expanding on crosshatching

There is almost no end to the effects that can be achieved by altering the space and direction of crosshatched strokes. Here, diagonal crosshatching has been used on top of vertical and horizontal strokes.

Describing shape

Traditionally, hatched lines follow the contours of the object. In this simple still life by George Cayford, the lines describe the curved shapes of the fruit and bowl, while straight lines emphasize the flat plane of the tabletop. A limited range of colours is interwoven to create tonal variations giving depth and form.

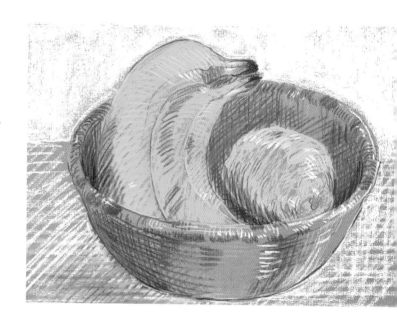

Mixing techniques

This still life shows just how varied hatching and crosshatching strokes can be. In the foreground they are roughly diagonal and have been softened in the shadow area by blending with a finger. Further up they curve around the bowl. On the fruit, a network of delicate hatching strokes over solidly applied colour ensure there is consistency throughout the picture.

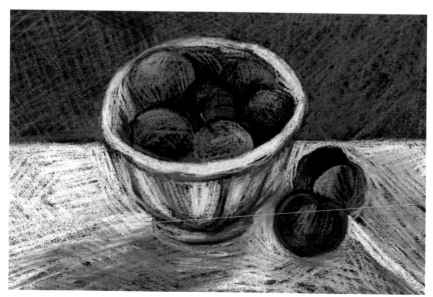

Feathering

Feathering strokes are quick, light, linear strokes made with the tip of the pastel over another colour, keeping the direction of the strokes consistent. The technique is a way of laying one colour over another to build up broken-colour effects or make modifications. For example, a colour that looks too bright can be knocked back by feathering with a more muted colour, while an area that looks dull or flat due to overblending or too much colour mixing can be enlivened by feathering with a lighter colour.

Vibrant effects

This picture was blocked in with side strokes, laid relatively flat, and colours were feathered on top. Because two pairs of complementary colours, red and green – and yellow and mauve – have been used, the effect is very vivid.

Feathering technique

Make light diagonal strokes with the tip of the pastel. Don't press too hard, but use a light, feathery touch to float a second colour on top of an existing one.

Subtle effects

In Geoff Marster's *IHI at Aldeburgh*, feathering is used very effectively to create subtly vibrant colour mixes and enhance the atmospheric qualities of the image.

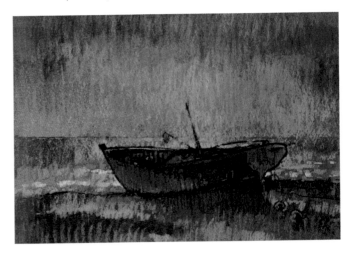

Scumbling

This is a technique common to most painting media, in which colours are applied over one another in light veils so that each one only partially covers the one below. You may find that you naturally use this method with pastel, since the medium rarely covers the previous layer completely. Scumbling can be carried out using short, light side strokes or circular strokes, loosely rubbed over the paper tooth to deposit a fine layer of textured pigment that does not obliterate or pick up the previously laid colour.

Scumbling light over dark

The hazy effect of scumbling can be exploited by working light over dark, to create a slight shimmer and enhance the colours' luminosity.

Scumbling dark over light

Scumbling a dark colour over lighter ones will knock back the original colours and give depth to the image.

Scumbling technique

Scumble a selection of colours over one another with side or circular strokes following different directions. If you combine closely toned colours, as here, they will mix to give the impression of a new colour, which has a more active surface effect than a smooth, blended mix, but a more delicate texture than a broken-colour effect.

SCUMBLING OIL PASTELS

Scumbling is a useful method for colour mixing oil pastels, which cannot be blended as easily as soft pastels. Here, reds, blues and mauves, have been scumbled over one another.

Colouring the ground

There is a wide range of coloured papers available to the pastel artist, but you may prefer to colour your own ground, using dry pastel, watercolour, acrylic or gouache paints, or perhaps tea leaves or coffee beans. In this way you can achieve the precise colour value you require, remembering that a coloured ground does not have to be of a single, uniform colour.

Dry pastel wash

1 Ground-up pastel can be applied as a dry wash to tint the paper surface. Hold a broken pastel – or tear the paper off a whole stick – over a plate and scrape it gently with a knife to produce a coloured dust. Dip a cotton wool ball or rag into the powder and rub it across the paper, pushing it well into the grain.

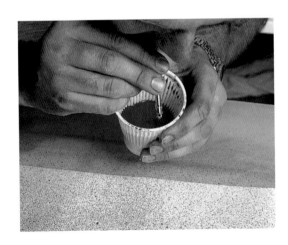

2 To create a smoother, more even finish, blend the dry pastel with a brush.

Stipple effect

For an interesting stippled tint, use a spray diffuser to distribute dilute watercolour, acrylic or gouache paint all over the surface.

Watercolour tint

1 When applying a watercolour ground to your paper you need to stretch the paper first, so that it will dry flat after the wet colour has been applied. Soak the paper thoroughly and lay it on a drawing board. Apply a strip of gummed paper tape all along one edge then smooth down a second strip along the adjacent edge. Work around the remaining two sides in the same way, making sure there are no wrinkles in the wet paper.

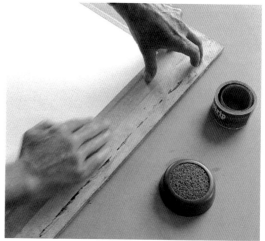

2 Mix up a large quantity of diluted watercolour paint. Use a large, soft brush to spread an even wash across the paper, working from side to side as you gradually extend the wash downwards. Allow to dry.

Traditional stain

You can also tint stretched watercolour paper following the Chinese example by rubbing damp tea leaves across the surface – or even by dabbing with a damp teabag. The contents of a cold cup of black coffee also make a good stain if dapped on with a cloth or painted with a brush.

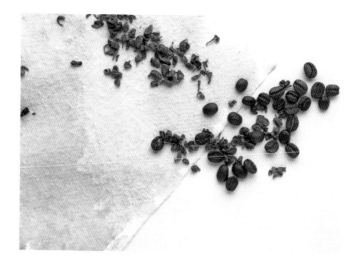

Texturing the ground

The paper you choose for a pastel painting will influence the appearance of the work to a limited extent, but you can also exploit texture in a more dramatic way by laying your own textured ground using acrylic modelling paste, acrylic gesso or pastels themselves. The textured marks will be visible through the overlaid pastel, resulting in a number of possible effects.

Acrylic modelling paste

1 Use a large bristle brush to apply the paste in roughly diagonal or multi-directional strokes. Leave to dry.

2 The pastel colour applied on top of the dry paste catches on the ridges, while the texture of the brushmarks adds an extra quality of movement to the finished painting.

Pastels

Crushed leftovers of pastels can be rubbed into the paper for a soft, grainy effect.

Acrylic gesso

1 Acrylic gesso can be brushed on with a bristle brush in the same way as acrylic modelling paste (see opposite). If you don't want to work on a white surface, tint the gesso by mixing it with a neutral shade of acrylic paint.

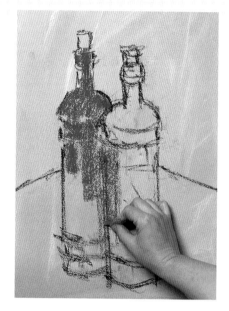

2 As you apply the pastel colours you will notice that the texture of the ground breaks up the pastel strokes. This method is exciting if you do not fight the texture but go with it.

Experimenting

Working on a homemade textured surface is an experimental technique, and you will soon evolve your own recipes for grounds. Before starting on *Apples and Tea*, Doug Dawson coated his Masonite ground with acrylic gesso, followed by acrylic paint, and finally transparent acrylic medium mixed with pumice powder. For the final coat, the artist used a paintbrush and diagonal strokes, which can clearly be seen in the finished painting.

Preparatory drawings

There are two ways to plan a pastel composition. Blocking in is the process of rapidly laying in the main shapes and colour areas before starting to develop the detail. The purpose is to establish the basic overall shape and tonal structure of the piece. Underdrawing, on the other hand, is useful when working on subjects that involve a variety of shapes that need to be carefully related. Making a more detailed preliminary drawing is a way to ensure the elements are correctly placed and in the right proportion to one another.

Though not essential, it can be a good idea to block in with hard pastels rather than soft, to avoid muddying the colours of subsequent soft pastel layers. Underdrawings should be made with pastel pencil, hard pastel or charcoal, never graphite pencil, which is slightly greasy and repels soft pastel pigment.

Blocking in

Identify the main shapes and tonal bias in your subject. The quickest way to block in is to use side strokes to apply broad, light patches using minimal pressure, but you can use the tip or edge of a pastel stick if preferred. Remember that this is a preliminary stage and try not to overwork the pastel: you may encounter problems keeping the colours clean and strokes distinct when you start to build up the detail. Here a sketchy drawing has been used to help outline the overall shape.

Pastel underdrawing

Choose a colour, or colours, of pastel pencil that show up clearly on the paper and that blend with the colours of the subject. Rough in the positions of the various objects by drawing light contours, concentrating on outlines. Once the general design has been established, you can begin to add in the pastel colours.

Charcoal underdrawing

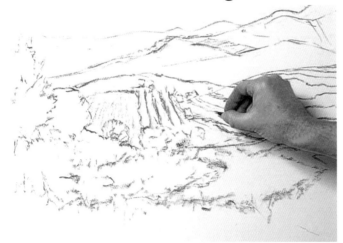

1 Hold a charcoal stick loosely and sketch the main lines of the underdrawing. Any errors can be rubbed off lightly with a finger or rag. The rubbed-down charcoal leaves a grey smear, but this will not affect the pastel colour.

2 Once you are ready to apply pastel colour, flick the drawing with a rag and most of the charcoal will fall away, leaving a light image to work from.

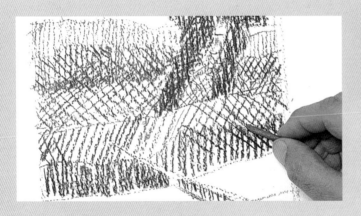

SHADOW AREAS

When making an underdrawing with charcoal, light crosshatching in the shadow areas makes useful reference for later stages of the work. Don't forget to dust down the charcoal with a rag before you apply the pastel colours.

Building up

There is one general rule about developing a pastel painting, which is that you should never bring one area to an advanced stage of completion before you begin the next. The best approach to building up a composition is to work all areas of the image to the same level of surface quality and visual detail at each stage, before moving onto more complex or intricate elements. If you complete one particular area in full detail before applying yourself to the next, it is difficult to achieve an image that has balance and consistency. Painting is a process of constant evaluation. You need to keep the entire image fluid so that you can make changes as you work, and if one area is highly finished you will not be able to work over it in this way.

Soft pastel

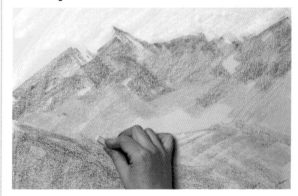

1 Lightly block in the main shapes and colours with hard pastels. To guide your later work, identify any areas of dark tone, but do not attempt to describe the shapes precisely.

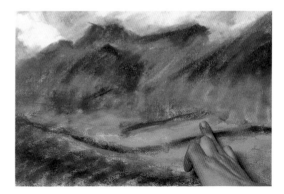

2 Still keeping the treatment broad and avoiding details, use soft pastels to build up colour effects by blending and overlaying. When you are working on the middle area take care not to rest your hand on the previous work.

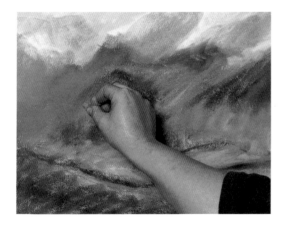

3 Assess the picture from time to time to decide how much more work it needs. A little detail – a mountain stream, some middle-ground trees – will bring this landscape into focus.

Hard pastel

1 Make an underdrawing to outline, and loosely shade in, the basic shapes.

2 Put in the initial colours using linear strokes, hatching and some shading.

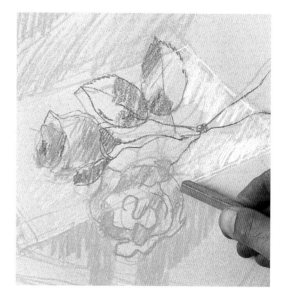

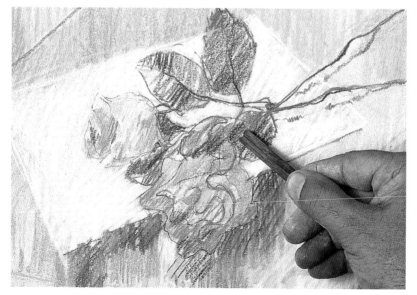

3 Gradually develop the colour detail, introducing some additional hues and tones. Continue using the same techniques to build up the image in layers.

Oil pastel

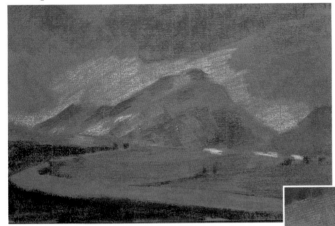

1 Use side strokes and loose shading to block in the main colour areas.

2 Build up the range of tone and colour by thickly overlaying the oil pastel. Blend the colours and soften the texture where necessary using a rag dipped in white spirit or turpentine. Continue layering and blending over the whole image.

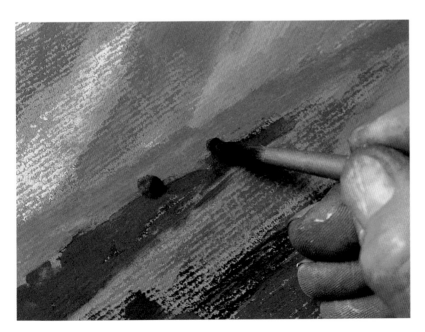

3 Details can be painted in at the final stages using a brush. Dip the brush in white spirit and use it to pick up colour from the end of a pastel stick, then transfer to the surface.

Building up strokes

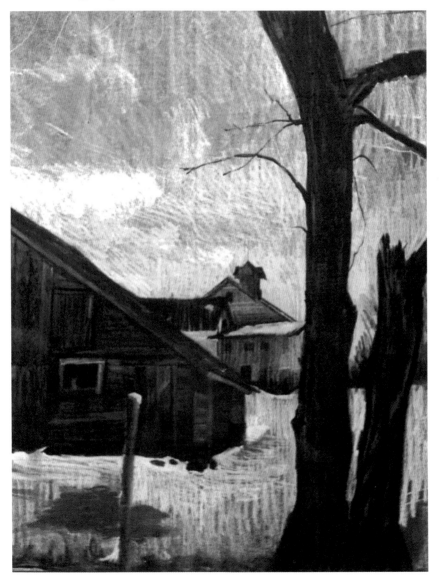

In John Elliot's *Winter at High Point, New Jersey* the tonal
balances of this image supersede the colour interest. Built up
areas of vertical and horizontal linear marks describe the
planes of the wooden buildings, contrasted with the hatching
and crosshatching in ground and sky.

Tutorial **Building a painting**

This painting of a kitten uses quite a limited palette of soft pastels. To depict the fur, gradations of greys and browns are built up layer by layer, to imitate the soft, fluffy look. These areas are blended with a finger, while the face is defined more sharply in contrast.

1 The artist starts by lightly blocking in the shape of the cat and marking out broad areas of fur, suggesting the kitten's markings.

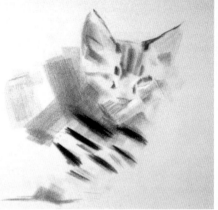

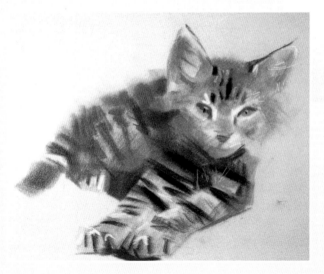

2 The bulk of body is mapped out using a variety of strokes in different tones of grey and brown. The artist uses stronger markings in black to define the forehead, and smudges them into the other colours to increase the soft, hazy look.

3 Now the details are put in. The artist uses a torchon to blend the pale area around the eye. He aims at maximum definition in the features, but takes care to keep the soft, velvety texture.

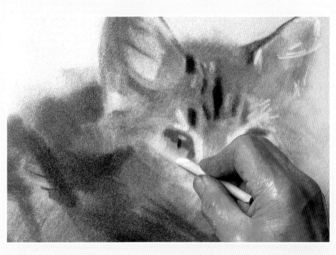

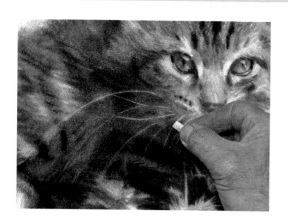

4 The finishing touches are concentrated around the head area. A mass of built-up colour vividly suggests the texture and markings of the fur. To bring out the details of the cat's features, the artist draws in the whiskers with long sweeping strokes of white.

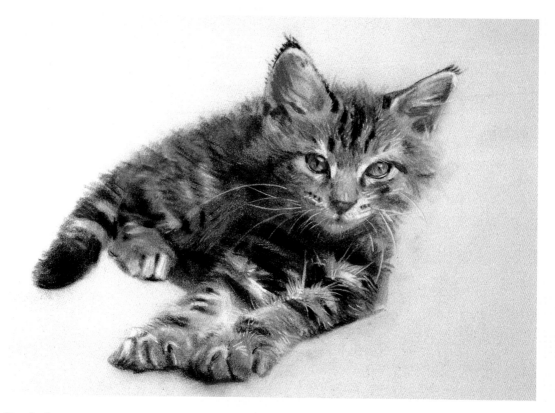

Ken Jackson *Kitten*
The central area of the picture is more detailed so the viewer's attention is drawn to it. Care must be taken to avoid overworking these details. In contrast, the artist has used his fingers to smudge the outside areas of tail and paws to increase the furry look, leaving the face itself crisp and clear.

Highlights and shadows

Highlights and shadows give a two-dimensional painting the feeling of three dimensions.

Highlights represent the points of light most intensely reflected from the surface of an object, and they add sparkle to a pastel rendering. Highlights are usually added with quick, decisive touches of a white or light-coloured pastel. You should apply highlighting only in the final stages, since this enables you to judge the highest tones against the other colours and prevents dirtying these lighter coloured applications with subsequent colours.

Shadows help to model form and give the subject a place in a composition, rather than floating on the page. To understand highlights and shadows it is essential that you look carefully at your subject.

Highlighting

Highlights give your work sparkle and help to define shape. Apply the edge of a white pastel stick firmly over the existing colour. It will mix slightly with the colour beneath to create a natural effect.

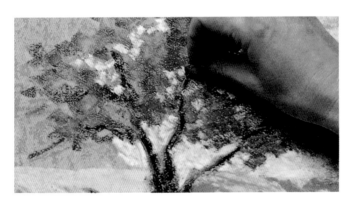

Defining light

Without these 'sky holes' – patches where the light comes through the foliage – the tree will look unrealistic.

Defining shape

In this portrait, linear strokes of white define the eyes, nose and mouth. The side of the pastel is used for the highlights on the nose and upper lip, and a blunted point gives a softer, rounded highlight to the mouth.

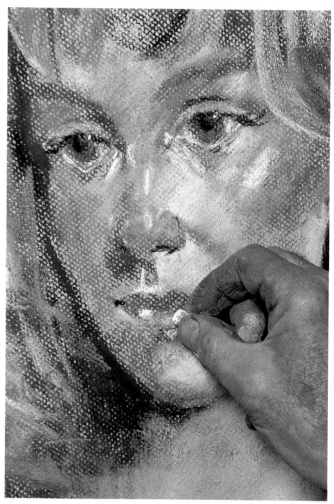

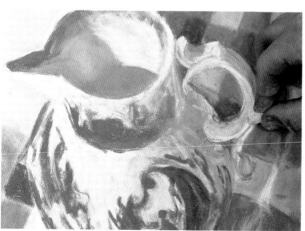

Reflective qualities

Smooth materials such as ceramics, glass and metal throw off the most intense highlights. This ceramic jug is lit from the left, so the lip, rim and handle are strongly highlighted.

Subtle highlighting

Soft-textured forms, such as flower petals, do not reflect light strongly, but need gentle highlighting. Use light strokes to maintain textural contrast.

Grounding shadow

In *Study Of The Artist's Hand,* the shadows cast by the hand where it touches the surface stop it from appearing to float in mid-air. John Barber uses lightly hatched strokes, smudged with a torchon, to mark out the parts in shadow.

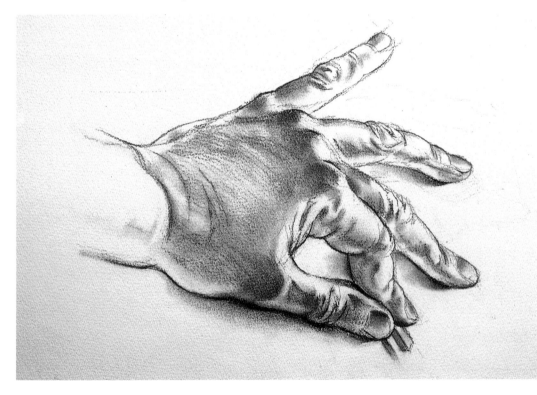

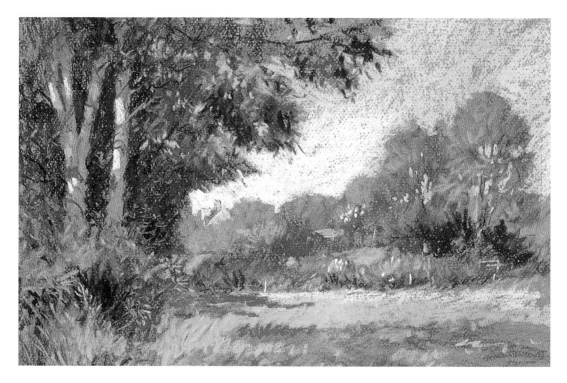

Foreground shadows

Shadows can play a vital role in a composition; they often provide that essential touch of foreground interest, as in Alan Oliver's *Summer Morning*. However, care must be taken to ensure foreground shadows do not become too dominant. Here the artist has worked lightly, leaving patches of bare paper between strokes of green to achieve a lively colour mix.

SHADING TO MODEL FORM

Heavy shading can create areas of flat, solid colour that give emphatic modelling to solid forms. Shade one colour into another to create highlights and shadows.

Tutorial **Colour accents**

Colour accents are the touches of colour you use to lift a pastel work, relating to local colours, lights and shadows. An accent is a small mark, so you can be surprisingly bold with its colour value and still find that it works effectively in relation to the surrounding colour areas – a patch of strong violet giving richness to a dark cast shadow, for example, or a streak of brilliant pink lighting the far horizon.

1 This pastel study is near completion. The natural variation in the flower colours provides bright colour accents, but the foliage in the background lacks depth and detail.

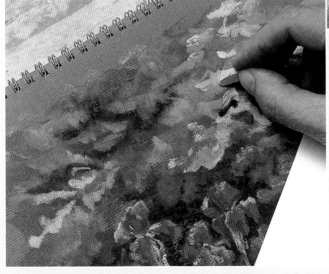

2 Touches of pale blue and yellow are put in to indicate glimpses of sky and sunlight reflecting on the leaves.

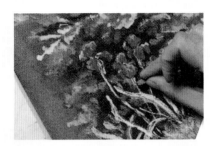

3 The shadow areas behind the flowers are strengthened using warm brown over black to contrast with the greens and yellows.

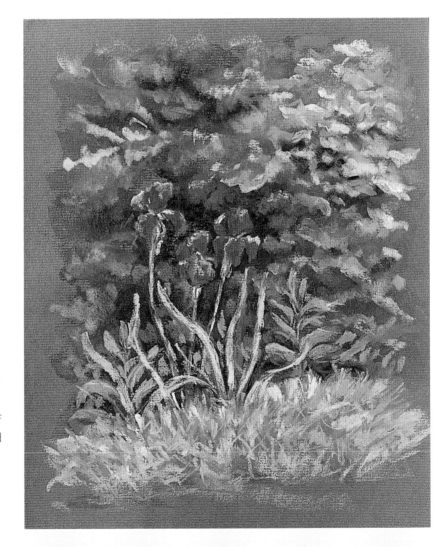

Judy Martin *Spring* The colour accents give more definition to the form and texture of the leaf masses and enhance the sense of depth between foreground and background elements.

Erasing

While it is true that you cannot erase a pastel line as cleanly as a pencil one, and that it becomes more difficult to erase pastel as you build up the layers, there are still ways of making corrections. In the very early stages, when the pastel is thinly applied and still fairly loose on the surface, you can use a brush to flick off much of the pigment. To remove a line more thoroughly, use a kneaded eraser or bread, which makes an effective cleaner. Do not use an ordinary rubber eraser because this may damage the paper as well as push the pigment particles deeper into it. In the later stages, working over areas you are unhappy with is a good solution, as long as you take care not to overwork. However, heavy pigment can be scraped away with the flat of a craft-knife blade, so all need not be lost if a small change needs to be made to save an otherwise perfect picture. Oil pastels cannot be erased in the usual ways, but white spirit can be used to cleanly wipe off colour.

Using a brush

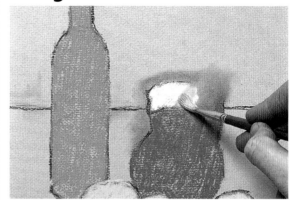

1 If you spot a mistake after you have blocked in the picture, simply flick lightly with a bristle brush to remove the top layer of colour. At this early stage the colour has not been pushed into the paper, so it comes away easily.

2 To clean the surface sufficiently for reworking, you may need stronger measures, so rub off the remaining colour with a ball of cotton wool.

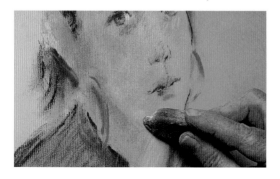

Using a kneaded eraser

A kneaded eraser has a slightly tacky consistency that picks up loose pastel without the need to rub the surface heavily. Shape the eraser to a point or sharp edge, depending on the quality of the mark you wish to erase and the area it covers. Use gentle dabbing motions to lift the loose colour. A faint trace of the marks may be left on the paper.

Using bread

Shape a small piece of soft white bread into a firm wad. Dab the bread onto the surface to pick up loose colour. Once the surplus colour has been removed, rub the surface gently with a fresh piece of bread to further erase the marks.

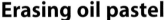

Erasing oil pastel

To make corrections to an oil pastel work, dip a rag or cotton wool ball in white spirit and use this to wipe off the colour. It should come off cleanly and the white spirit evaporates almost immediately so will not harm the picture.

Using a knife

Scraping back with a knife allows you to re-establish a workable surface when you have built up layers of pastel thickly and find it difficult to apply further colour. Use the flat edge of a lightweight craft knife to scrape the colour, following the grain of the pastel marks to avoid damaging the surface.

SCRAPING FOR EFFECT

The technique of scraping with a knife can be used as a way of introducing very fine linear texture to a picture. Here, the tip of the blade has been used to draw into heavily laid colour, creating the whiskery effect of the seed heads and enhancing the complexity of the varied directional lines in the grasses.

Fixing

The decision to use or not use fixatives is a matter of personal choice. Some artists believe that it spoils the freshness of the pastel colours, others fix regularly between stages of work, while others choose to fix only at the final stage. If you are going to use fixatives, do so sparingly. Over wetting the surface can cause blotches and colour runs.

Aerosol cans of fixative are now CFC free and are convenient to use. If, however, you definitely do not want to use a fixative, you can 'fix' the surface of a finished work by pressing a sheet of tissue paper over it to push the pastel particles more firmly into the paper grain.

Spray fixing a finished painting

Make a test spray to check that the nozzle is clear and the spray quality is even. Hold the can about 30cm (12 in.) away from the paper and spray from side to side, covering the whole area. Avoid over spraying, which wets the surface and can make the colours run or mix.

Fixing in stages

1 Applying a light spray of fixative at intervals as you work will seal the surface before application of further layers, preventing new colours from mixing with earlier ones.

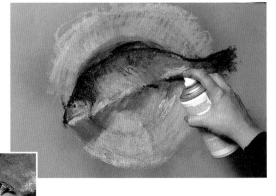

2 You can also use this technique if you like to fix your work but are disappointed by the dulling effect created by fixative. Spray it on during the painting process, then add the final layer of pastel colour or highlights.

Spraying from the back

To avoid over spraying a painting with fixative, spray the back, using the same method as for the front. The fixative will soak through and dampen the pastel to hold it in place. This technique works best on medium- or light-weight papers.

Non-spray fixing

An effective alternative to spray fixative is to lay a sheet of tissue paper over the painting, cover with a board and press down. The pressure pushes the particles more firmly into the paper. Take care not to apply too much pressure, however, since this will alter the surface textures of the painting.

SPRAY FIXATIVE SAFETY

• Always read the instructions on a can of spray fixative before you use it.
• Always spray in a well-ventilated area, to allow the unpleasant fumes to dissipate.

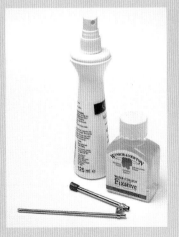

NON-AEROSOL FIXATIVES

When travelling, especially on aeroplanes, non-aerosol fixatives can make a useful alternative to usual spray cans. Hairsprays are available in non-aerosol containers and make a cheap and satisfactory alternative, or you could take a bottle of fixative and a diffuser.

Further Techniques

Masking

Masking when working in pastel is especially useful for achieving sharp edges and crisp outlines. When you want a straight edge for the side of a wall, or a clean edge for a bottle, but you don't want a hard drawn line, paper or masking tape can be used to cover the areas you do not want filled with colour.

Clear outlines

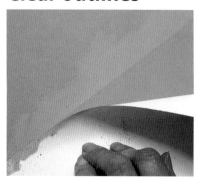

To produce sharp, straight edges, hold the straight edge of a sheet of paper where required on the pastel paper and work the pastel up to it. Remove the paper carefully to avoid smudging.

Using masking tape

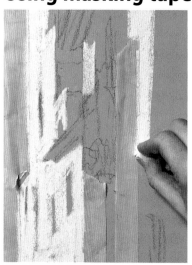

1 Masking tape can be used to help achieve straight, sharp edges, such as the division of planes between buildings. Work up to and overlap the tape.

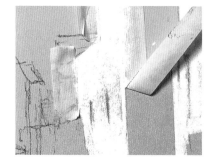

2 Remove the tape to reveal a crisp edge.

Abstract effects

This abstract pattern shows the range of different textural effects that can be obtained by working into and around masked shapes, varying the density of the pastel strokes and overlapping the colours.

Complex shapes

1 For shapes that are more complex than straight lines, draw the shape on tracing paper and cut it out. The remaining paper forms the mask.

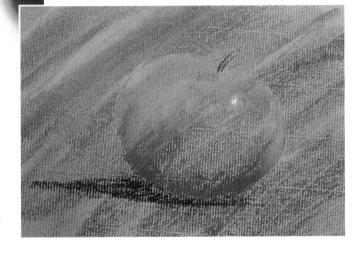

2 Apply the background colours that will surround the shape before you apply the mask. Hold the mask in place as you fill in the edge details.

3 When the mask is removed the edges are crisp and well defined.

Precision effects

In *Still Life With Natural and Manmade Objects,* Paul Bartlet shows how a mix of masking methods can be used with soft pastels to create very precise effects and clean edges.

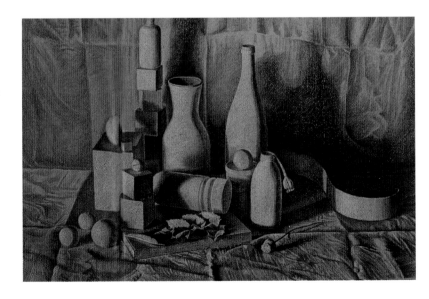

Wet brushing

In this technique the colour is applied to the paper in dry form then spread with a wet brush. Adding water to soft pastel turns it into a form of paste that quickly fills the paper grain, so this is a good way of covering the surface.

The extent to which pastel colour can be spread depends on the type of brush used. A bristle brush, used with fairly heavy pressure, leaves little of the original line visible, but a soft watercolour brush will take colour only from the top of the paper's grain, so that the character of the pastel strokes is retained. The strokes you use also affect the wash. Washing over side strokes gives a dense, fairly even effect, while the linear pattern of scribbled or hatched strokes will be retained through a diffused, pale tint of washed colour.

Oil pastels can also be wet brushed, simply by replacing water with white spirit or turpentine.

Wet brushing soft pastel

1 Lay down your pastel strokes, in this case broad side strokes.

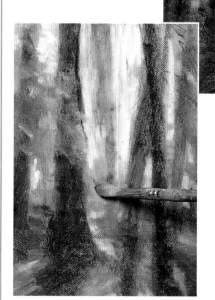

2 Dip a brush in clean water and begin to spread the colour, taking care to follow the direction of the pastel marks. Clean the brush before applying and wet brushing new pastel colors.

Even wash

Light wet brushing over solidly shaded pastel will leave the grain and texture still visible. Move the brush outward from the pastel colour and the tinted water will spread a lighter tone over the paper.

Line wash

Linear and gestural strokes stand out clearly against the paler tone of the wet-brushed colour. The water picks up the colour of the pigment but does not actually dissolve the pastel mark.

Wet brushing oil pastel

1 Lay down your strokes in oil pastel, in this case an overall shading.

2 Dip a bristle brush in white spirit or turpentine and use this to spread the colour. The pastel can be pushed around like paint, here in a loose, scumbling motion.

3 The spirit makes the pastel greasier, so when you work back into the still-wet paper with dry pastel the colour will spread easily.

Impasto

Traditionally an oil painting technique, impasto refers to paint applied thickly with a brush or knife, so that raised edges where the paint stands out from the canvas are clearly visible. In pastel work you can achieve an equivalent result by using the full strength and texture of the pigment in heavy strokes, either by laying impasto strokes directly on the surface or by building them up over thinner, grainy colour.

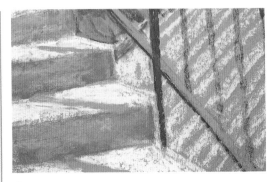

1 Work thickly, overlaying strokes to begin building the rich surface texture.

2 The increasing density of pastel layers will result in the gradual disappearance of the paper colour.

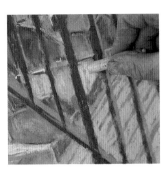

Three dimensions

The ridges of solid pigment in the impasto strokes of this sky catch the light, creating an almost three-dimensional effect. For this method to be successful it is essential that the thick colour is not touched after any area has been completed.

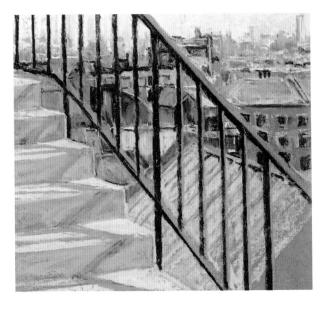

3 The finished painting will look similar to a brush painting in oil or gouache, with a cohesive, opaque surface.

Wet colour

This impasto sketch was completed by working soft pastel into wet fixative, so that the colour remained pliable.

Impasto effects

In *Between Showers*, Margaret Glass has achieved an impasto effect on the tree branches close to that of an oil painting.

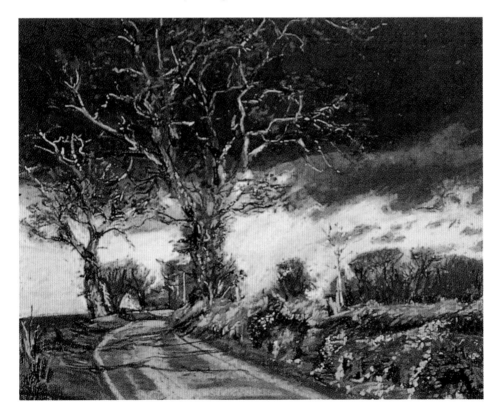

Sgraffito

Sgraffito is the technique of scratching into one layer of colour to reveal another beneath. It is important that you lay the first colour heavily, so that it fills the grain of the paper, and that you apply the second colour thickly, to cover the first. To achieve a good effect, the colours must be worked out in advance so that you have sufficient colour and tone contrast to make an impact.

This effect is more successful with oil pastels than soft pastels, because they adhere more strongly to the paper. If you do use soft pastels, it can be a good idea to fix the first layer.

Variations for this technique include using more than one colour in each layer; applying a textured rather than flat top layer; and applying pastel over ink or paint instead of a previous application of pastel.

1 Apply a thick first layer of pastel, then add a layer in a different colour on top. Use the tip of a craft-knife blade to scrape fine lines into the top layer, revealing the layer beneath. Take care not to spoil the surface of the paper.

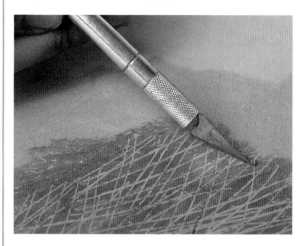

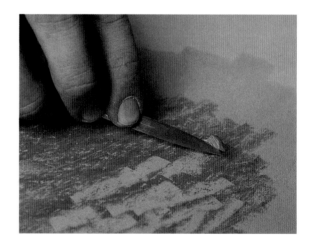

2 Use the flat side of the blade to scratch back in a wider stroke. The marks made can be extremely varied, and the colour range increased by applying further layers and scratching into either the one below or down to the lower layer.

Varying texture

In this detail of David Ferry's *Construction Site* you can see how sgraffito techniques have been used to increase the range of textures in this lively work. The harsh, calligraphic quality of the scratched marks ties in with the industrial theme of the whole piece.

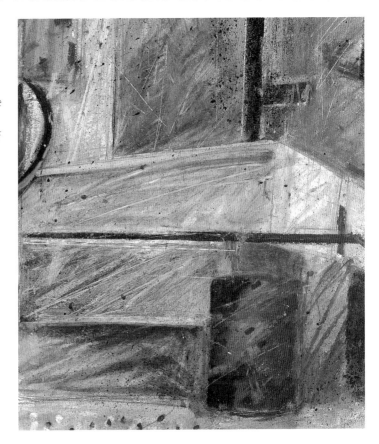

Multi-layering

Several colours have been layered over one another and a knife used to scratch away the top layers. The sharp point of the knife allows very fine lines to be drawn, and the technique is ideal for this delicate, if sharp, subject.

Underpainting

An underpainting is a variation on an underdrawing, the difference being that the colours and elements used in the underpainting often become an integral part of the actual pastel painting. An underpainting can be made in watercolour or acrylic paints, and be as simple or as complex as you choose. It may consist of only broad areas, or you can take the process further by fully establishing the tonal structure and sketching in important shapes. The advantage of this method is that it allows you to cover the paper quickly, so that you can complete the painting with fewer layers of pastel, allowing areas of the underpainting to show through. You can also achieve intriguing effects by using contrasting colours for the underpainting, such as warm yellow under an area to be cool blue-grey, or red under green. The ground colour showing through the pastel strokes produces an exciting, vibrant effect.

Remember that watercolour and acrylic paints can only be used on pre-stretched watercolour paper (see page 69), which won't buckle when wet.

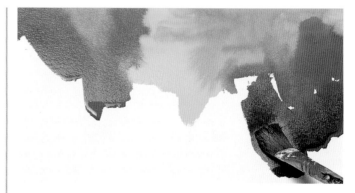

1 If the subject is colourful, it makes sense to give it a colourful ground. Working on watercolour paper, use a broad brush to apply strong washes of watercolour or acrylic paint.

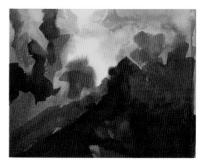

2 Cover the entire surface with paint, applying darker colours where you want to build up dark tones of pastel.

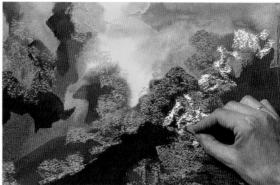

3 Allow the underpainting to dry thoroughly, then apply the pastel colours. Here short side strokes in various colours are used to create broken-colour effects suggesting foliage and flowers.

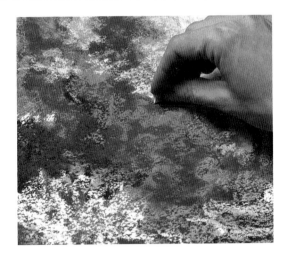

4 Continue to build up the picture. Do not try to cover the underpainting: the essence of this method is to leave parts of the watercolour showing between and beneath pastel marks.

Using brushstrokes

In *View Over Allotment*, a large-scale work, Patrick Cullen has treated the underpainting as an integral part of the building up process. Instead of applying flat watercolour washes he used expressive brushstrokes designed to complement the later pastel marks. In fact, it is hard to distinguish one medium from the other.

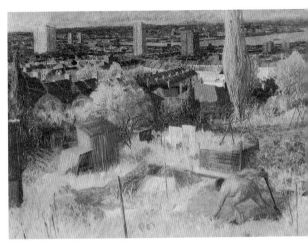

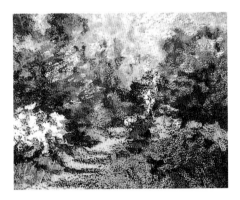

5 Flecks of yellow and orange underpainting enliven the areas of green and enhance the vibrant colour effects.

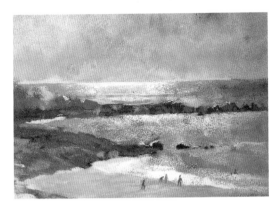

Visible colour

Sunglade, by Claire Schroeven Verbiest, has been worked in soft pastel over a watercolour underpainting, which is still visible in the sky area and rocks at left.

Charcoal and pastel

Charcoal and pastel have similar textures, and as such they make ideal partners. As well as being a medium for making preliminary drawings, charcoal can also be used within a pastel drawing to reinforce lines, build up areas of tone, or soften colours.

Charcoal can be particularly effective for figure studies and portraits, or any subject where the emphasis is linear. There is a danger of charcoal dust spreading onto and sullying the pastel colours, so it can be a good idea to fix a charcoal drawing before applying pastel colour.

Charcoal over pastel

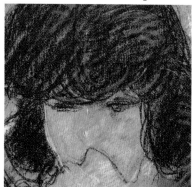

1 Gradually build up the pastel colours to describe the form, then use charcoal to emphasize the dark tone of the hair and delineate the eyes.

2 Use the charcoal to signify linear detail and shadow areas, as in the folds of the shirt. Work the charcoal over the pastel then touch in the final pastel highlights and colour accents.

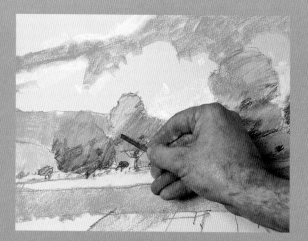

SUBDUING COLOURS

Charcoal is useful for toning down any area that looks too light or bright. Lay charcoal on top of an overassertive colour and lightly blend the two, to subdue the colour, turning a bright green or blue into a grayed-down version of the same hue.

Pastel over charcoal

1 Use charcoal to create a detailed monochrome drawing of your subject. Contrast sharp lines with loosely worked shading and graded tones, working up the dark tones quite heavily. Charcoal is a very dry medium and so does not clog the paper tooth.

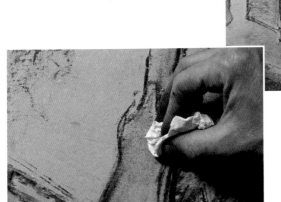

2 Smoothly graduate light and mid-tones by rubbing the charcoal with tissue. Dust off the surface and apply a light spray of fixative before applying pastel colour.

3 Block in the first layers of pastel colour using the tip and edge of the pastel stick. Concentrate on broad colour areas, then add highlights to counterbalance the dark pastel tones. The initial charcoal still shows through as a linear framework.

4 Use charcoal again where necessary to re-define the framework of the composition and give emphasis to the forms.

Coloured pencil and pastel

However dexterous you are at manipulating pastels, you will probably still find it difficult to sustain a hard, sharp line using this medium. When your subject suggests that linear qualities be combined with a softer technique, coloured pencils make a useful complement to pastels. All types of pastel combine readily with coloured pencils, and the pencil can be worked into and over the pastel colour. Like pastels, coloured pencils can be manipulated to exploit their linear qualities or to produce colour masses and complex surface textures, so a combination of the two is generally sympathetic.

1 Loosely block in the drawing with pastels and pastel pencils to establish the general shape of the subject.

2 Use a waxy coloured pencil to define contours and develop a sharper, more distinct image.

3 Enhance textural qualities with line work and shading laid in with waxy and chalky pencils.

4 With the structure clearly defined by the pencil work, use pastels to introduce highlight areas and block in the background. The contrast of hard line and grainy colour gives richness and depth to the rendering.

Patches and pattern

Steve Russell used soft-leaded waxy pencils and pastel pencils to provide the bright colour scheme of this sunlit view. In *Cala Honda, Spanish Landscape*, the shapes are simplified to emphasize the rhythms and patterns of the landscape and buildings. Using broadly shaded patches of bold colour gives an exotic impression, enlivened by formal pattern elements in the foreground.

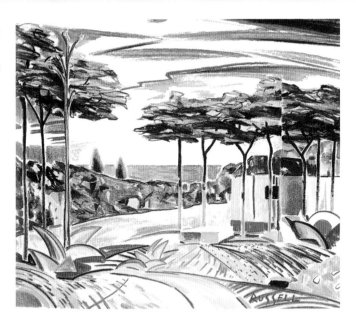

Line details

Container Plants, by Jane Strother, is an illustration for reproduction in print. The more intricate line detail is worked in coloured pencil over oil pastel. The pastel is rubbed in places for massed colour, with individual strokes used to delineate flower and leaf forms.

Watercolour and pastel

The translucency and fluidity of watercolour make it an interesting complementary contrast to the opacity and density of pastel. Both media have brilliant colour qualities but quite different surface characteristics. The watercolour is usually applied as a wash and then, when dry, worked over with pastel. Pastel can also be worked into a wet or damp watercolour wash, in which case the pastel particles will spread in the moisture, creating interesting textural effects.

Watercolour should only be used on pre-stretched watercolour paper (see page 69) that won't buckle when wet, and it is a good idea to choose a rough, cold-pressed paper with plenty of tooth to hold the pastel granules.

1 A watercolour wash is often used for the background of a mixed-media watercolour and pastel painting. In this case, however, the sky and grass have been laid in with pastel. The diagonal strokes in the foreground suggest a grass-like texture and appearance.

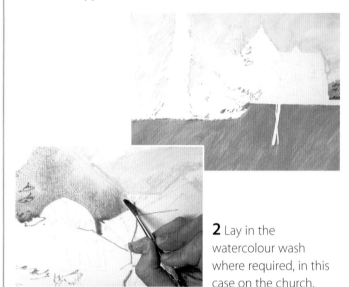

2 Lay in the watercolour wash where required, in this case on the church.

3 When the wash is dry, add in the pastel details, working over the watercolour. Already some interesting textural contrasts are appearing: the softness of the watercolour helps to separate the solid mass of the church from the foreground and sky.

4 You can also work watercolour washes over the pastel work, as has been done here over the black tree. When dry, touch in the details again with pastel, such as the patches of sky between the tree branches.

Textural contrasts

Sally Michel used watercolour for the background of this painting of her cat. The loose wash has created an interesting contrast in textures, with the fur of the cat conveyed by the thick build-up of pastel on the grainy surface.

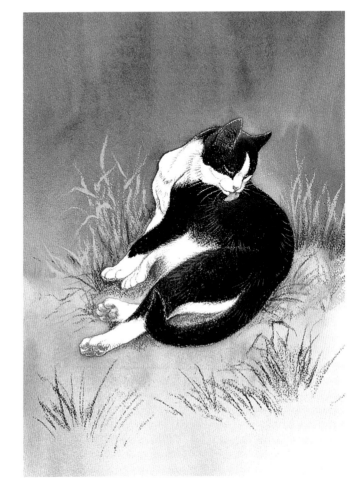

Layering techniques

Judy Martin's *Orchard in Normandy* uses watercolour and pastel in layers. To begin with the pastel was drawn over a watercolour base, but the two media were alternated in successive stages to intensify tones and colours and enhance the effect of light.

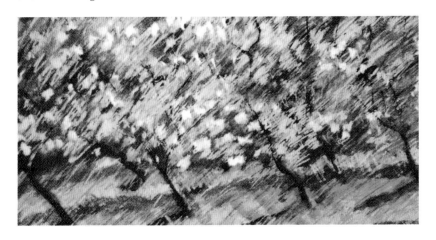

Gouache and pastel

Gouache and pastel provide similar colour character and complementary textures. Both are opaque media in which pure hues and tints are particularly brilliant, although gouache lightens slightly as it dries and its paler colours are highly reflective.

A good approach when combining these media is to let the gouache do the painting and take advantage of pastel's qualities as a drawing medium to provide detail and textural contrast.

1 Sketch in the composition then lay in washes of gouache to block in the main forms of the painting.

2 Use gouache to block in the basic shapes and colours of the composition.

3 When the gouache is dry, use pastels to draw in the fine details.

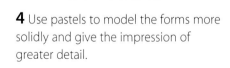

4 Use pastels to model the forms more solidly and give the impression of greater detail.

5 Finally, use pastels to add the highlights and shadows.

Exploring textures

In this gouache and pastel rendering, fine hatching and crosshatching are used to convey the varying textures of the ram's smooth head, the hard, ridged horns and the looser hairs on the body. In *Ram's Head*, Keith Bowen has used pastel to build up complex tonal gradations over thin gouache washes.

Dusk colour

Michael Lawes has used gouache paint in *Champs Elysees* to convey the deep blue of a sky at dusk. Light pastel colours were applied over the top to create the reflections while allowing the underlying colour to show through.

Acrylic paint and pastel

Artists' acrylic paints have the textural quality of oil paints, but can be mixed and diluted with water. This means that they can be handled like watercolours, heavily diluted to achieve translucent washes, or applied as solidly brushed, opaque colour or thick impasto layers, like oils. With more thickly worked acrylics, you can use pastels to draw into the paint to develop linear qualities and impressed textures. However, if you use acrylic very thickly it can be difficult to work pastel strokes over the dry paint: once the paint is thick enough to mask the surface of the paper you will have lost the tooth that helps pastel strokes to grip.

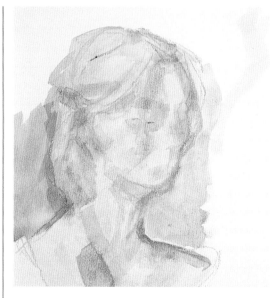

1 Make an underdrawing then block in the basic shapes with very dilute washes of acrylic paint.

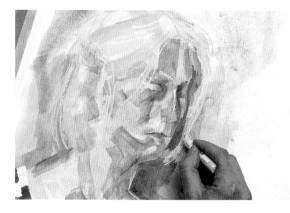

2 Overlay more washes to shape the composition further. When the paint is dry, use pastels to develop the details.

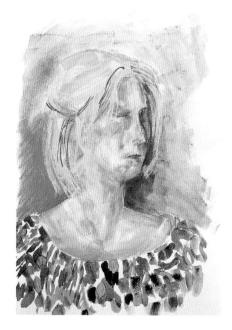

3 Apply further acrylic washes to strengthen the colours and integrate the tones. When dry, use pastels to draw in the lights and darks, shadows and highlights.

4 Combine acrylic washes and pastel marks by laying one over the other in different areas of the image to build up form and texture. Translucent washes overlaid on pastel will let the pastel marks show through, while slightly denser acrylic washes can be used to enhance tonal contrasts.

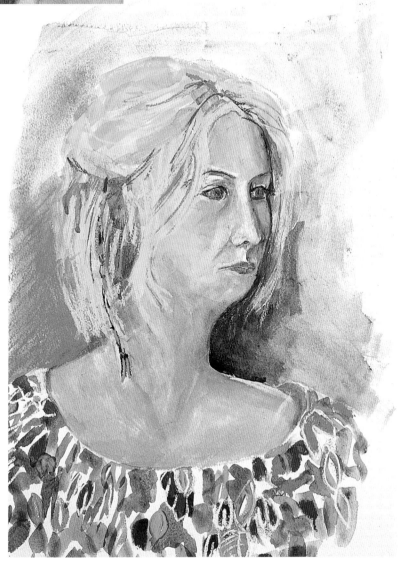

Oil paint and pastel

Oil pastel can be combined with oil paint to contribute additional linear qualities subtly different from those that can be achieved with a brush. Working into a thin layer of oil paint with the pastel tip actually grooves the surface of the paint as well as leaving colour traces.

If you prime the paper with acrylic gesso, or even leave it unprimed, the oil paint will dry quite quickly and because the paper absorbs some of the oil the paint will have a matt surface that blends well with the pastel.

1 Draw in the basic shapes of the composition, then rapidly block in the main colour values with thick oil paint.

2 Work into the wet paint with oil pastels, using them to hatch in the shadow areas, highlights and details.

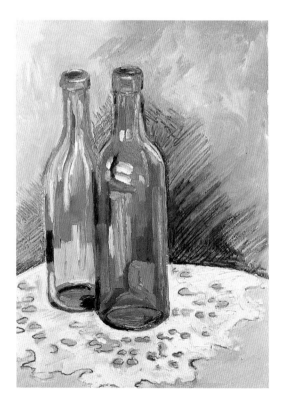

3 To produce a fine line, sharpen the pastel tips by shaving them with a knife.

4 Strengthen the background with pastels and use lines and accenting strokes to define the shapes more strongly. Highlights and intense shadows can be brushed in with bold dabs of solid, opaque paint.

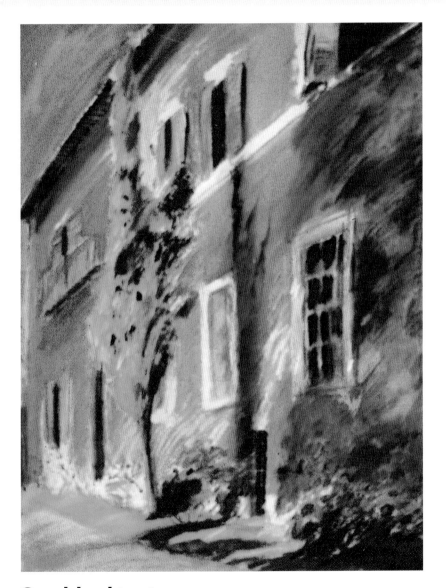

Scrubbed texture

In *The Red House*, Jane Strother used a combination of oil paint and oil pastel, vigorously rubbed and scribbled, to create the scrubbed texture of colour-washed walls.

Resist techniques

Resist methods are based on the incompatibility of oil- and water-based mediums. Colour is laid down using oil pastels, over which a thin wash of watercolour paint or water-soluble ink is applied. The greasy texture of the pastel repels the fluid colour and the paint settles into the paper around the pastel marks, leaving their colour and texture clearly visible. A light-weight pastel stroke leaves parts of the paper grain unfilled, so the paint will settle into these irregularities within the pastel colour as well as around the edges. With repeated applications of both media, allowing the washes to dry in between, a dense and complex image can be built up.

1 Draw your subject using oil pastels in as many colours as you wish and with heavy, boldly textured strokes.

2 Use a soft brush to paint a dilute wash of watercolour paint over the top, allowing the colour to flood over the pastel drawing.

3 The liquid colour will settle into the paper grain within and around the pastel marks.

Layering the image

This resist drawing has been built up in several stages with dilute watercolour over oil pastel. Loose washes of watercolour paint have been laid over the top of an oil pastel drawing of leaves. When the paint dried, parts of the pastel drawing were re-worked and further washes applied. The process was repeated once again to build up the density of colour and texture.

Dry resist

Debra Manifold has used an unusual variation of the resist technique to develop the rugged textures in *The Retreat*. The image was drawn with oil pastel, then vigorously worked over with soft pastel. As with the fluid impression usually associated with this technique, the dry colour adheres irregularly and creates a rough, broken texture.

Subjects

Landscape **Composing a landscape**

There are few hard and fast rules for landscape composition, but there are some general pointers to bear in mind. A painting in which the eye is led into and around the subject is exciting and satisfying, because the viewer takes part in the picture. To create this sense of movement, curved or diagonal lines, in the form of a path or river running from foreground to middle distance, for example, are often used as a compositional device.

Linear elements can be used within the image to create space by indicating direction, such as lines of trees converging towards the horizon.

Establishing a relationship between various parts of a picture, whether of colour, shape, technique or tone, is also key to creating a successful composition. As you work, always think about the painting as a whole and try to set up a series of visual links.

Finally, a painting needs an element of contrast, for example within shape, colour or tone. Rounded fluffy clouds could be the perfect foil for spiky trees, or use tiny touches of red or yellow, in the form of flowers or figures in the distance, to enliven large areas of green.

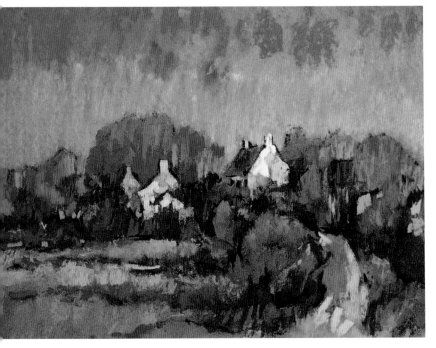

Lead-in lines

Subtle use of the conventional device of a road draws the viewer's gaze towards the central group of houses, which forms the focal point of *Cottages at St. Jacques, Brittany* by Geoff Marsters. Colour is also important to the composition: the eye is led by brilliant patches of acid green repeated from the foreground trees to the foliage in front of the houses.

Space through perspective

Perspective makes receding parallel lines appear to draw closer together until they finally meet. In landscapes, such lines are unlikely to be perfectly straight, but they still converge in the distance and observing this effect correctly will help you create the illusion of space. In *Fen Landscape* by Geoff Marsters, the lines emphasize the depth of the field and also depict the irregularities of the ground.

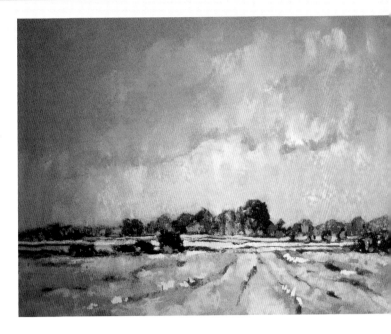

Linking colours

Sally Stride's *Oak in Winter* uses a palette entirely composed of cool colours. Pale blues and mauves are typically cool, but here even the reds and yellows are selected to inject crisp, clear tints rather than dense, saturated colours. The warmest note is reserved for the strong red-brown woven into the linear structures of the foreground trees that create the focal point of the composition.

Contrasting shapes and tones

The river in Lois Gold's *Autumn Light* draws the eye into the picture and divides the foreground into angular shapes, while the interplay of shapes is emphasized by avoiding detail. The curving shapes of woods and hills contrast with the angular shapes of the foreground, and the use of light, middle and slightly darker tones keeps the landscape lively.

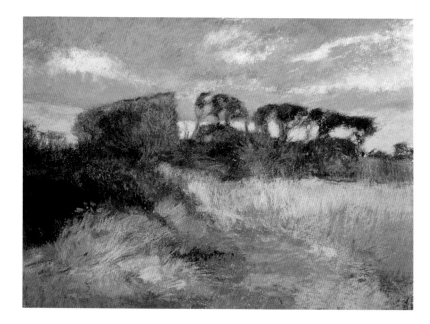

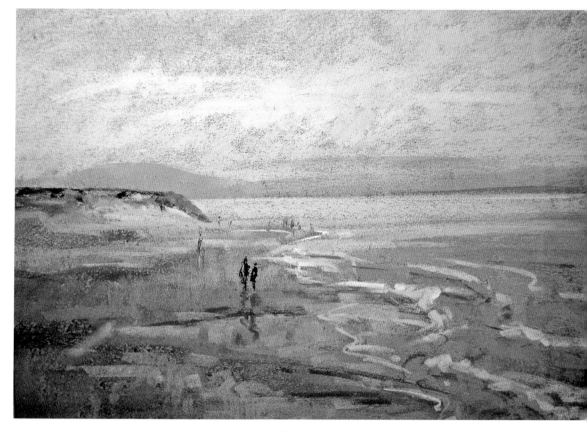

Diminishing size

In *September Evening*, Aubrey Phillips has made subtle use of perspective by bringing the curves of the waves closer together as they recede. However, it is the tiny figures at the far end of the beach that really suggest its depth and give a sense of distance; they are hardly more than dots and dashes in comparison with those in the middle ground.

Leading the eye

◀ The foreground should lead the viewer into the scene and this can be done partly by pastel marks. The diagonal marks on the left and the curve on the right of *Winter, Andalusia*, by James Crittenden, lead us to the dark line of shadow and upward via the vertical straight edge of the tree. The eye then follows the line of trees and is led downward again with the vertical strokes of grasses, so that it travels right around the whole picture.

Landscape **Light and landscape**

To paint realistic landscapes you must engage with the effects of natural light. The difference between a sunny and an overcast day is obvious, but the light also changes according to the time of day and the season. It can be difficult to fix such transient effects, but effective interpretation of light qualities comes from keen observation and confidence with your medium. Sometimes it helps to exaggerate contrasts of colour and tone and be bold in your mark-making: when you step back the individual elements marry into a striking image.

Cast shadows

In Eric Michael's *Journey to Zunil* the shadows cast from the trees create the effect of pools and rivulets of light and shade flooding across the ground. The tonal contrast is extreme, and the artist develops the variations in colour values at full strength, working in pastel over a watercolour base.

Sun and cloud

Unpredictable days when sun alternates with cloud produce the most exciting lights. One part of the scene will be brightly lit and another dramatically dark or small clouds will cast intriguingly shaped shadows on an otherwise luminous scene. Rosalie Nadeau captures the effect of the sun emerging from clouds to sparkle on the water in *Cove Cloud Break*. Note how the distant hills in shadow create a dark shape that balances the cloud mass above.

Evening light

Light from a setting sun provides the stunning contrast of long shadows and warm luminous colours. In *Last Light*, Debra Manifold has treated the colour areas very loosely and broadly, seeing the composition as an arrangement of semi-abstract shapes. Grainy side strokes applied over a dark green ground create the overall pattern of light and shade, with highlights and accents worked in bold linear marks. Glimpses of the ground colour showing through both light and dark colours soften the brighter tints and harder-edge qualities.

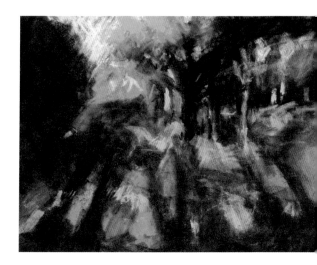

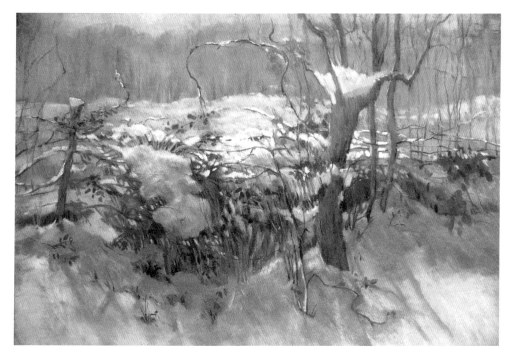

Winter light

Although you sometimes see strong blue skies in winter, the light is usually more diffuse than in summer and the shadows softer, with a blue bias caused by reflection from the sky. In *Winter Hedgerow*, Jackie Simmonds contrasts blue-grey and mauve shadows with the warm red-browns of the hedgerow and dead leaves.

Landscape **Atmosphere and landscape**

A straightforward record of a particular environment may in itself convey a mood, but you can also take a more deliberate approach and use composition, colour or technique to communicate more than just an immediate visual impression.

Viewpoint and organization of a composition contribute to the mood of the subject. A building or object within a landscape can be made to appear isolated and remote by placing it centrally within a broader landscape. Harsh lighting or exaggerated colours can create a sense of alienation, while naturalistic colour, even with strong lights and shadows, is more reassuring. A landscape's atmosphere is also affected by the weather and time of day, while a clever use of strokes can add pace and mood effects.

Colours and their tonal values are often associated with mood. For example, neutrals and pastel shades are more serene than pure, bright hues, and gentle gradations of tone similarly create less impact than strong contrasts of light and dark.

Broken colour

Elizabeth Apgar Smith uses diagonal hatching strokes for the sky contrasted with horizontal hatching for the land area in *After the Rain*. The broken-colour effects indicate the harshness of the passing weather and the striking use of a limited palette of light and dark depicts the transient nature of the storm.

Using viewpoint and colour contrasts

David Prentice has used a high viewpoint for *Coloured Counties – Laura's War* to create an unusual configuration of land and sky, laid in with bold side strokes and linear marks. The strong impression of light and atmosphere is enhanced by the interplay of warm and cool colours, pure hues and neutral tones, and the technique of gestural drawing gives the whole picture an active, rhythmic unity.

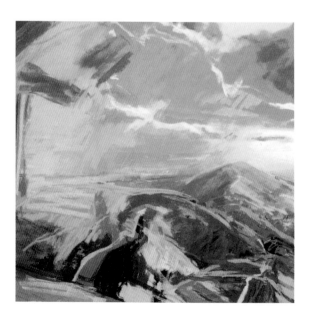

Warm and cosy

Claire Schroeven Verbiest chose to use a vivid red ground colour for *East Foothills*, a bold decision that has given warmth and richness to the whole colour scheme.

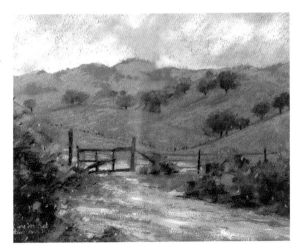

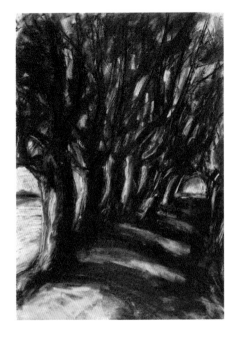

Harsh lines

In *Twickenham Riverside* Irene Wise uses the linear quality of hard pastel to structure the dense network of tree branches and develop their threatening, shadowy tones. Where colour areas are more broadly blocked in, the medium has a harsher grain than that of soft pastel, which suits the menacing mood of the composition, described with strong blacks and a limited colour palette.

Isolation

A threatening mood in Jane Strother's *The Yellow House* is created by the stormy sky, the colour and texture of which give weight to the image. This atmosphere is underlined by the apparent isolation of the house, centred within the composition, but the sunlit colours of the house and foreground landscape create an element of contrast.

Tutorial **Atmospheric landscape**

Pastel is the perfect medium for gentle, misty light effects. The only possible danger is that you may overblend to produce light tones and gentle gradations, or lose sight of colour altogether and produce a picture in shades of pale grey. In this demonstration, Steven Bewsher works with vibrant colours in a range running from light to mid-tone. Although he blends colours in the early stages, the blends are overlaid with firm pastel strokes that give the painting an additional surface interest that also enhances the subject matter.

▶ **1** Once the main shapes of the landscape have been blocked in using grey and earth brown, the next important step is to establish the light source. To ensure that the sky and the water reflecting it are firmly linked, yellow is applied to both areas simultaneously.

▲ **2** For the time being, the artist avoids hard edges and definition in the water; these will come later. Instead he concentrates on covering the paper with light blue-grey and yellow, laying down light side strokes and rubbing them well into the grain with his finger. The colour scheme is based on the blue/orange and yellow/mauve complementary pairs, so these colours are established to act as a key against which to judge colours for the trees and foreground.

▶ 3 The artist does not want the greens to detract from the blue/yellow contrast, so a mid-tone grey-green is used, knocked back further by being applied over the original grey. It is important to have a good selection of these neutral colours for landscape painting.

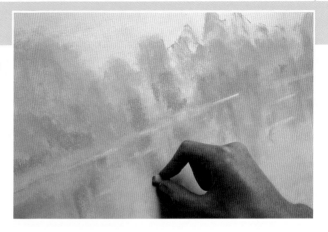

◀ 4 Brighter hues are now gradually worked into the faint whispers of colour. A vivid orange-yellow is taken around the outer edges of the trees that catch the light of the setting sun.

▶ 5 So that the painting develops as a whole, the artist moves from area to area, bringing each one to the same stage of completion. Touches of reflected sunlight are added to the top of the mountains, using the direction of the pastel strokes to define the shapes.

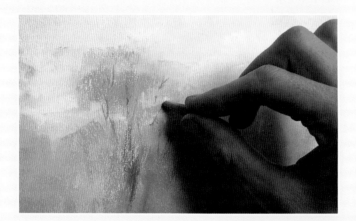

◀**6** The trees are left as soft-edged shapes, with tones and colours merging gently into one another, but a touch of crisp definition is needed to explain their structure. Trunks and branches are drawn in with the tip of a red-brown pastel, held tightly near the end so that lines do not become too heavy and uniform.

▶**7** The main reflections in the centre of the picture have been painted with broad horizontal side strokes, but the tall, spiky trees on the right cast a stronger reflection, which is described with squiggling point strokes that suggest the broken surface of the water.

◀**8** Throughout the painting process, the artist has worked the sky and water together, and having made some small, but important, adjustments to the sky he can add the final touches to the water. He creates ripples by working strokes of yellow over the previous yellows and blues. The yellow chosen is paler and less assertive than that used for the sky because reflected colour is not as bright as the light source itself.

Steven Bewsher
Lake View at Grand Teton National Park
The finished picture is full of atmosphere, and has a lively sparkle, due not only to the brilliance of the colours but also to the skilful and sympathetic use of the medium. The mid-toned blue-greys, green-greys and mauves used for the darker areas 'sing' against the brilliant orange-yellow around the edges. The shapes of the mountains are suggested by the way the pastel marks are used, with short side strokes varying in direction to follow the lines of the rocks, and point strokes picking out small sunlit patches.

Landscape **Skies**

How you deal with painting skies depends partly on the style of your image. A sky composed of many individual marks building up into a complex feathered texture or mass of broken colour can be surprisingly effective, but if the sky becomes much busier than the landscape it will begin to dominate the picture and ruin the sense of space. On the other hand, an evenly coloured, open sky may look too flat if treated oversimply. To avoid lifeless renditions you can use two or three closely related tints to give a little depth and variation, blending these if necessary to create a coherent effect. You can even give the sky an unnatural colouring that expresses the mood of the image and forms an appropriate backdrop to the landscape subject.

A landscape painting will prove less than successful if the two main areas – sky and land – are not 'tied together' sufficiently. Aim to create a link, be it by colour or technique, between the two, so that the image works as a whole.

Blended colour

In *Golden Fields,* Lois Gold's sky is worked using several applications of colour blended with the hand to give gentle gradations and remove hard edges. The soft effects and glowing colours of the sky contrast with the crisply drawn lines of the foreground.

Feathering

Geoff Marsters develops the colour nuances of a greying sky by feathering broad vertical strokes to create gentle gradations of delicately varied tints. In *LT229, IH88, IH265 at Aldeburgh*, the vertical emphasis is repeated and emboldened in the treatment of the foreground, the two areas cut through by the strong horizontal arrangement of the boats.

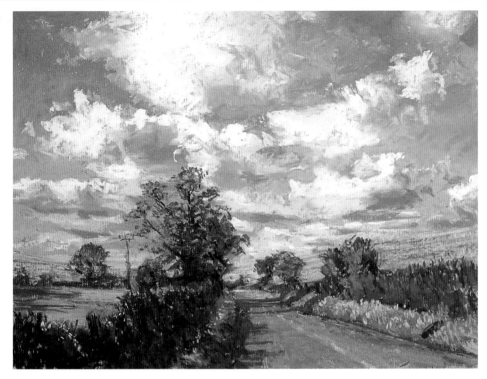

Creating movement

Unless care is taken, clouds can very easily appear static and solid, but in *After a Spring Shower*, Margaret Glass has given an impression of swirling movement by the way she has varied both the weight and the direction of her pastel marks. The warm, sandy colour of the paper contrasts with the blue of the sky and small patches have been allowed to show at the edges of the clouds. This enhances the sunlit effect and creates colour links with the foreground and trees, where the same method has been used.

Cloud perspective

There is a grand impression of space in Lionel Aggett's *Hawthorn, Cornwall*, partly due to the aerial perspective and partly to the careful observation of the clouds. The largest cloud is at the top of the sky, with horizontal bands of cloud becoming closer near the horizon.

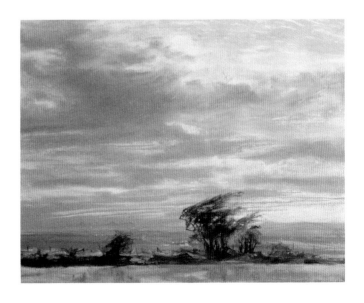

Landscape **Water**

Water in a pastel landscape can be interpreted in many different ways; however, because it has no fixed character, you need to pay careful attention to what you actually see in a given situation. Reflections, for example, can appear as a network of colours and abstract shapes, or as a startlingly detailed, inverted picture of the surrounding landscape. Clear water has no colour of its own, but borrows those of its surroundings in the form of reflections of the sky or landscape features. Moving water has infinitely changing patterns of form, colour and texture, while still water can change from a flat, mirror-like surface to a complex mass of tiny ripples with the touch of a breeze.

Stressing patterns

The viewpoint for *Torrential Stream* by C. Murtha Henkel is high, looking down into the water. At a lower viewpoint you would not be able to see the curve of the river or the patterns of the eddies. Pattern is always more obvious when viewed from a distance or from above, because the forms become flattened.

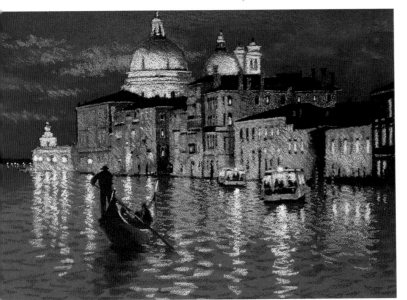

Stippling

Stippling is used to great effect in *Grand Canal and the Salute* by Michael Lawes, especially in the reflections in the water. The broken-colour effect successfully depicts the undulating movement of the water.

Hard edges

Reflected shapes and colours often appear as quite hard-edged patterns. In *Down the Flight* (1988), Lionel Aggett's confident interpretation of colour values reproduces that visual quality, although the individual pastel strokes applied to the textured ground appear soft and grainy in close-up.

Stillness and movement

In John Elliot's *Homer's Rocks*, the surface of the sea is treated quite flatly in oil pastel, with densely shaded, cold greys, except close to the rocks where the foam breaks white and the moving water is shot through with a stronger green-blue.

Landscape **Trees**

A tree can be the subject of a detailed pastel study or make up a part of an overall landscape. It can be the focal point of a painting or act as a guide leading the viewer into the composition. Trees make interesting subjects because of the variation in their natural shapes, textures and colours, according to the individual species and the seasonal changes they undergo. Not only are there dramatic changes in structure as deciduous trees grow and then shed their leaves, but colours and textures also change.

Botanical identification is not an essential requirement when it comes to pastel tree studies, but it is important to pay attention to specific visual qualities, such as typical outline, branch structure and leaf shape and colour.

Darkness and light

The glow on this red maple, seen against fog, relies on the stippling technique. In *Red Maple in the Fog*, Bill James has built up the textured, autumn leaves from the dark, silhouetted branches to the final, very light effect.

Shimmering suggestion

Kitty Wallis began *Morning Blue* with a watercolour underpainting. Varied pastel strokes and colours have been added in layers to create an impression of shimmering light. No green has been used, instead deep turquoise-blue over deeper blues and warm browns gives the impression of green, so the trees are completely convincing. Pastel marks suggest the leaves.

Leading the eye

Using a tree as the focal point of a landscape view gives an immediate sense of scale. The curving branches of Sally Stride's *Autumn Tree* lead the eye in from the right edge of the frame to the central space of the landscape. A free, gestural approach is applied to the form and texture, and the arrangement of colours helps to define the different elements of the composition.

Creating drama

The drama in *Cypress* by Kitty Wallis stems from the low viewpoint, and the fact that the dark triangle of trees is set against a pale but glowing sky that occupies a large part of the picture space.

Landscape **Flowers and foliage**

The amount of detail contained within any landscape view can be focused more closely in individual studies of foliage and flowers. The textures of plants and flowers are staggering, and close inspection of even the most common species will reveal incredibly complex and intricately patterned structures. Putting this down on paper gives the pastel artist the opportunity to experiment technically and find out how the different kinds of pastel marks convey the extraordinary range of natural leaf and flower forms.

Linear marks

In *Cherry Tree in Blossom*, Geoff Marsters uses a consistent pattern of small hooked linear marks to describe variations of texture and local colour, relying on the balance of colour to define form.

Gestural technique

In Anthony Eyton's *Irises*, the mass of foliage is freely translated with gestural drawing. The confident handling of the complex structure and varied colour range produces a striking painting.

Light and dark

Contrasts of light and dark create the texture of the flowers in *Azaleas with Pines* by Bill James. Short pink and crimson pastel strokes are used for the flowers and dark greens and blacks for the underlying foliage. The blurry distance is created by blending soft pastel strokes and the colours used on the ground echo those used elsewhere in the picture, unifying the painting.

Organizing the subject

Subjects like this one are not easy to handle. The area of empty grass contrasts with the busy display, as well as placing it in space. In Rosalie Nadeau's *Three Phlox in Red* the pale flowers on the right and the red ones in the middle create lines leading the eye toward the dominant blue blooms.

Urban subjects **Buildings**

An individual building often has a special character that makes it an attractive subject. When you choose to depict a building, try to identify its particular features and find ways of highlighting them. Its appeal could be stressed by viewpoint or lighting. It is not necessarily a good idea to paint a building from directly in front – a three-quarter view conveys greater solidity as well as looking more interesting. Sunlight provides shadows that help to define the structures and give tonal contrast.

The building's setting can also convey spatial and atmospheric information. A house set in an expanse of countryside may call for a distant view that takes in the surrounding area and hints at the isolated lives of its inhabitants, whereas a building in a busy town may be depicted merging into its surroundings and context.

Viewpoint and lighting

This subject might look unexciting seen from the front and under a grey sky. Here, however, the sunlight brings the colours to life and creates a good shadow that, together with the three-quarter viewpoint, gives solidity to the structures. Rosalie Nadeau unifies the composition of *Forget-me-not, Buttercup* by using the same red-browns on the foreground trees and the building's roof.

Seclusion

This isolated house, masked by a few trees, provides an unusual and intriguing composition that suggests the remote nature of life in this landscape. Jane Strother uses oil paint and oil pastel to bring out strong colour contrasts and varied textures in *The White House – High Summer*. The two media are freely mixed and overlaid.

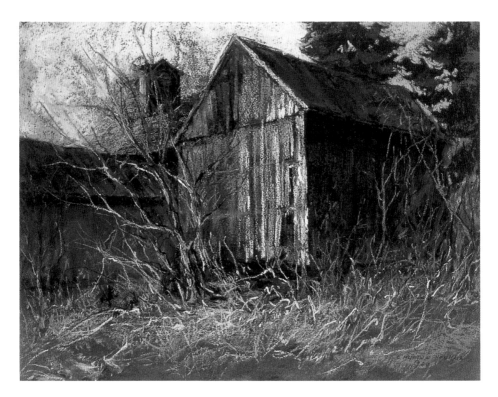

Atmosphere

This building has the atmospheric feeling common to many old deserted barns. In *Illuminated Barns*, C. Murtha Henkel chose to exploit this by using predominantly dark tones and muted colours, with sharply drawn trees and grasses giving dramatic emphasis. She has conveyed the impression of weather-worn wood by dragging white pastel over the darker colours just enough to catch on the grain of the textured canvas.

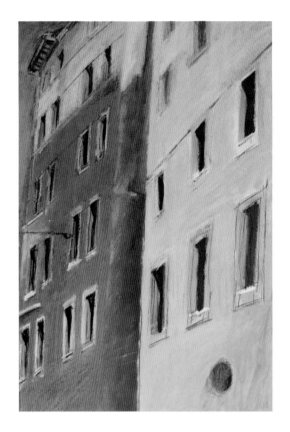

Town context

In *Rome Flats*, Jane Strother crops right into the uniform façades of the buildings so that neither their base nor apex is seen. This creates a confrontational image that is softened by warm, inviting colours.

Afternoon light

When painting *Barn Outside Waterford*, Bill James smudged several pastel colours together on the side wall to create a smooth texture and depict the late afternoon glow of light.

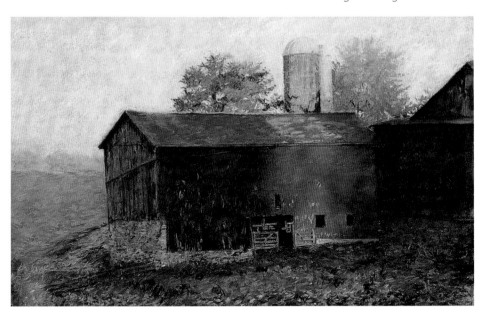

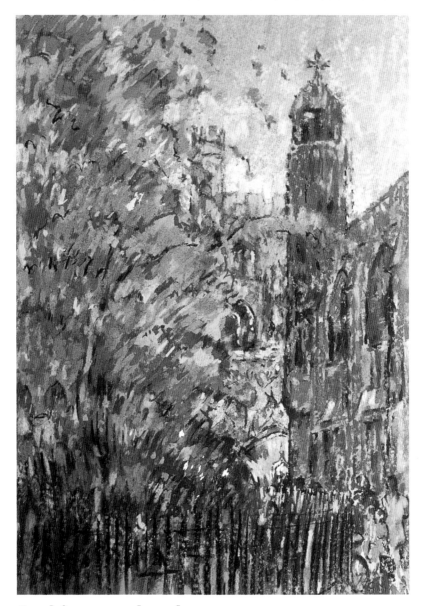

Architectural style

Although the building has little detail, its general proportions and the shapes of the windows are sufficient to communicate its style and identify it immediately to anyone familiar with the town. In *St. John's College Gate, Cambridge*, Geoff Marsters conveys the rich hues of a sunlit fall day by using the same vivid palette for the trees and the building, which prevents the building from becoming too dominant.

Urban subjects **Depicting details**

When dealing with urban structures an attractive picture can often be made not simply from the whole building, but from an architectural detail, such as a door, balcony or wall with carved stonework. Depicting details can be easier than handling the intricacies of perspective over a large scale, but care needs to be taken with composition and lighting. For example, it is rarely wise to place the chosen feature in the middle of the picture. Working on a sunny day will provide good contrasts of tone.

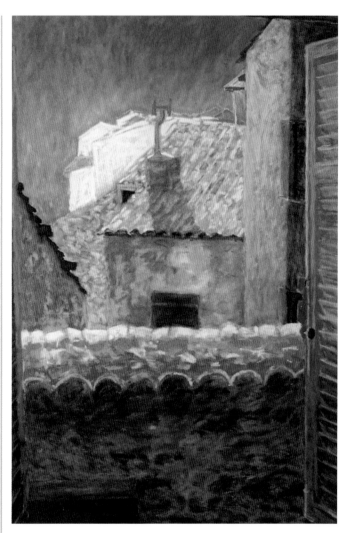

Broken colour

In *Window, Valensole*, Patrick Cullen has concentrated on the view from a single window and used broken-colour techniques to provide surface interest. He has built up the picture in short strokes of differing sizes and directions so that the overall effect is far from flat. The size and shape of the pastel marks suggest the texture of the walls and roof, and the colours are varied and exciting.

Pattern and texture

Much of the interest in *The Yellow Door* by Margaret Glass lies in the patterns and textures of brick, wood and stone, contrasting with the freer forms of foliage and grasses. On the door, long downward strokes follow the direction of the wood and patches of unpainted paper suggest its texture. The impact derives from the organization of shapes and tones, with the dominant rectangle of the door balanced by the triangle of light stonework on the left and the curves of the cobbles below.

Contrasting shapes

Sandra Burshell has made a pleasing arrangement of tones, colours and shapes in *East Livingston Place, Old Metairie*. Pointed shapes and diagonal lines lead the eye to the focal area above the door, and the dark shadow above helps it to stand out. The low evening sunlight gives a rosy glow to the walls and casts shadows that strengthen the forms.

Urban subjects **Urban settings**

Towns and cities have their own distinctive flavour that you can tap into by paying attention to prominent buildings and the way in which they are arranged. Some towns have wide, straight streets with regimented rows of houses; in others, streets are narrow and buildings vary. You can create the feeling of urban bustle by including people, cars and typical street furniture, such as lamp posts, signs and benches.

Alternatively, a convincing townscape can be depicted from a high viewpoint, such as from an upstairs window in a house or block of flats. From this position you can see the entire layout of the town and use it to make an exciting composition of rooftop patterns.

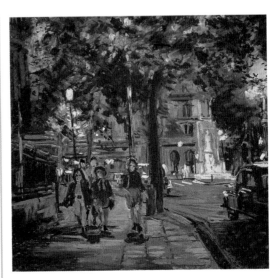

Including figures

While including one or two figures in an urban scene can bring it to life, people instantly attract the eye and so can dominate a composition. In *Summer Evening, St. Martin's Place*, Margaret Glass has avoided this risk by treating the group of girls very broadly, and setting up strong tonal contrasts on the building and statue behind, so that this area becomes the focal point.

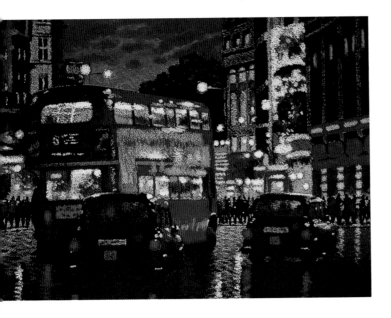

Capturing a city

The red bus and black cabs instantly place this London scene. In *Bus Turning in Piccadilly* Michael Lawes has blended and layered pastel colours to create a range of surfaces and city textures. Light over dark and dark over light produce wonderful reflections on the buildings, vehicles and road.

Window views

Patrick Cullen painted *Valensole* from a window, providing a high viewpoint that allowed him to emphasize the almost abstract patterns made by walls and rooftops set at varying angles. He chose to minimize detail to ensure a satisfying arrangement of shapes and colours.

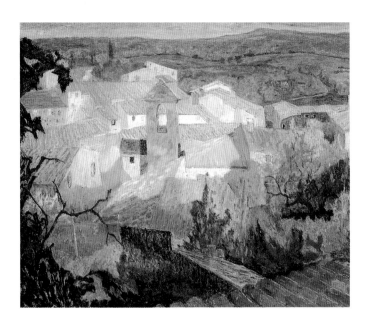

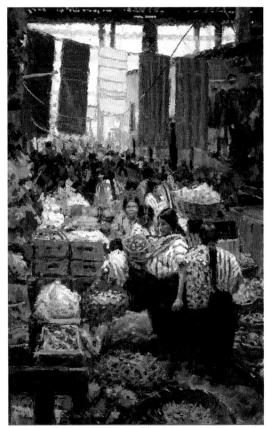

City bustle

The busy atmosphere of *Indoor Market, Santiago*, by Eric Michaels, is encompassed in the long view of the market hall, which allows so many elements of the activity to be seen.

Tutorial **Urban landscape**

Railway stations make excellent subjects for anyone interested in urban landscapes. Many stations are of architectural interest and the people who throng the platforms or concourses are focused on their own concerns, and unlikely to be bothered by you. In this demonstration the effects of light in an urban environment are explored, in particular the challenge of addressing natural and artificial light in the same scene.

1 The artist begins with an underdrawing to establish the main lines and tonal structure of the composition. The first colours are then blocked in with light side strokes, building up to heavier applications.

2 The middle tones are gradually built up as the blocking-in continues, and gradations of tone are blended together using a soft brush. This glowing red-brown is the key colour in the painting and with this established the artist can now consider the other colours.

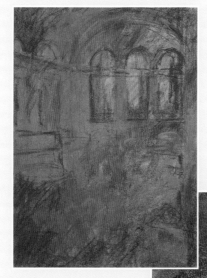

3 The artist builds up the next colours more thickly, laying yellow ochre over the red-brown.

4 The string of red lights, and the way they reflect on the walls and window arches, is one of the most attractive features of this subject. The accents will be added later, but for now the artist concentrates on the broader area of reflected light, laying orange over the red-brown and blending to soften the transitions of tone and colour.

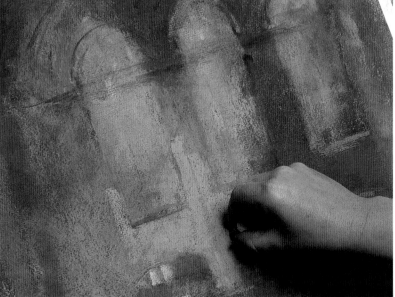

5 The artist is constantly assessing one colour and tone against another, heightening and muting colours as required. A warm, mid-toned blue for the windows contrasts with the rich browns and ochres. The window wall is darker than the sky at the top, but lighter below; where light is reflected from the strip lights beneath, so pastel is used quite heavily to lay light ochre over the previous darker colour.

6 Once the main area has been built up to a satisfactory stage of completion, with dark areas and bright patches of reflected light, the details can be added. Vivid colour accents, defining a few chosen details, are laid in. A short length of bright red pastel is used to make small, square marks for the lights running around the tops of the walls.

7 Further colour adjustments are made. The artist drags the side of a pastel stick over the earlier colours, applying very light pressure so that it catches only on the top grain of the paper to create a shimmering, broken-colour effect. The effect of successive veils of colour is more vibrant and exciting than flat colour.

8 The people are treated as no more than suggestions, with no colour used for individual garments and no precise delineation; their role is mainly to reinforce the vertical emphasis of the composition. They are laid in with black pastel and worked around with light brown.

Debra Manifold
Grand Central Station
The picture has a lovely, rich glow deriving from the skilful manipulation of colours in a limited tonal range. The direction of the pastel marks plays an important part in stressing the vertical emphasis of the composition, and the decisive, upright strokes used for the central area of light have been strengthened in the final stages to form a more definite focal point and lead the eye up to the tall windows and arch above.

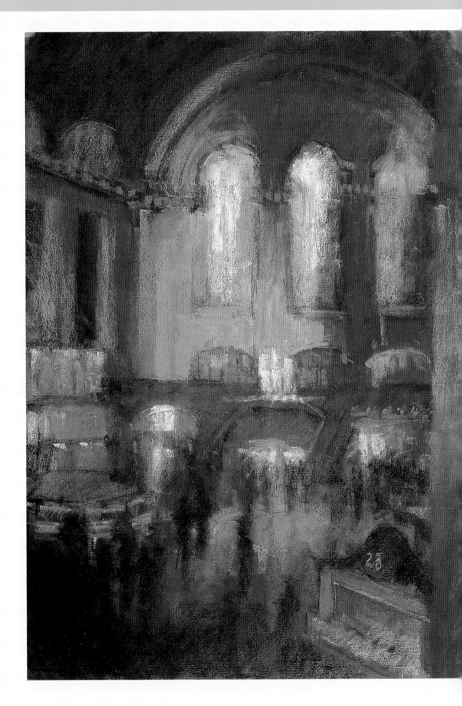

Still life **Found groups**

As you look around for still-life subjects you will undoubtedly find accidental arrangements that provide the perfect material for a pastel rendering. These arrangements are known as 'found groups', and found subjects can be anything from clothes in a cupboard to a plant on a windowsill, or books on a shelf.

A still life usually has a theme, giving the impression that the objects belong naturally together, and in a found group such a theme already exists. Once you have found such a group you can still alter its composition, but bear in mind that the essence of a found group is spontaneity, so don't make it look too ordered.

Out and about

The beauty of the found group is that it can be discovered anywhere, inside or out. The relationship of the three boats invites further exploration. In *Baob at Dinner Key*, Bill James has recreated the worn surfaces of the boats and their reflections in the water by blending and layering pastels on paper. The result is a tranquil, softly coloured scene transfused with light.

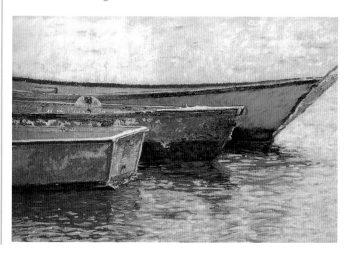

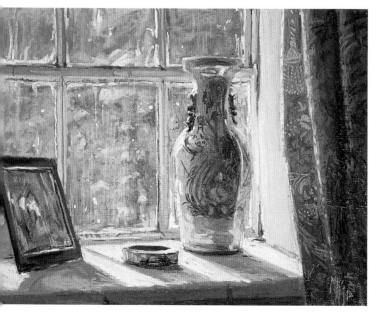

Simplicity

Since this found group is situated on a windowsill, the primary theme of *The Blue Vase* by Margaret Glass is light, which comes in from behind the group so that the shadows play a vital role in the composition. Light and shadow create diagonal stripes that counterpoint the verticals and horizontals of the window frame. The pattern on the vase is played down so as not to complicate its strong, simple shape.

Minor adjustments

This group was essentially happened upon and adjusted to improve the composition. In *Reflections* by Sandra Burshell there is, however, a carefully planned colour theme based on the contrast between warm red-browns and turquoise walls. The artist muted and 'blued' the green of the plant so that it does not conflict with this.

Repetition and variation

The repetitive shapes of the deckchairs in Lionel Aggett's *Wear the Green Willow* (1983) form an interesting still-life group, yet the chairs are also sufficiently varied in their different heights and spacings to avoid a regimented effect.

Still life **Fruit**

Choosing fruit as a still-life subject allows you to explore the varying qualities of form, texture and colour that each piece encompasses. You may choose to focus your studies on the sculptural elements of volume and contour, modelling the forms with subtle gradations of light and shade, or prefer to concentrate on the colours and textures, working the pastel marks to incorporate variations of surface detail. You may want to isolate the subject and treat it as a self-contained form, or decide to give it a context that includes other objects or a background.

Modeling simple forms

The simple shapes in this composition are a strong vehicle for the artist's exceptional skill as a colourist. In Sally Strand's *Lemons*, each of the lemons is modelled with a range of subtle hues from warm yellow and pink to cold blue, green and lilac. The effect of brilliant sunlight derives from bold definition of the highlight areas.

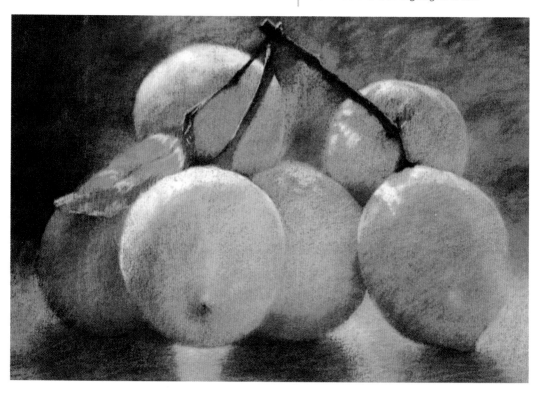

REMEMBER
When you are working with simple forms, the quality of light is particularly important. Angled light will emphasize the structure of the object, whereas an even spread of light may flatten the forms and reduce the range of visual interest.

High viewpoint

The strong pattern in Catherine Nicodemo's *Fruit Still Life* derives partly from the way the fruit is arranged and partly from the high viewpoint. This enhances shapes because forms are less apparent and it separates the objects from the flat plane on which they are resting. The artist has emphasized the separation by omitting any shadows beneath the fruit, so that they look as though they are flying upwards.

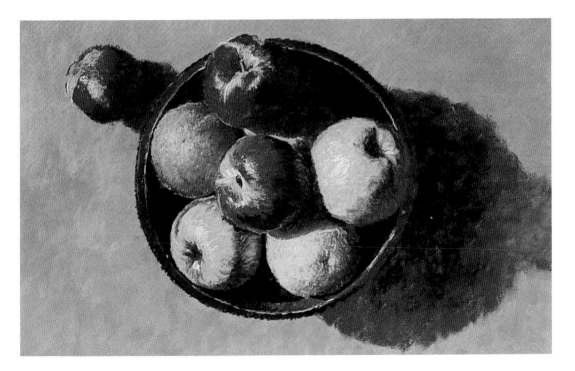

Blending and layering

Also drawn from a high viewpoint, *Apples and Oranges* by Bill James provides a good example of blending and layering. The textures of the fruits – the pitted skin of the oranges and the smooth apples with their many tones of red and green – are rendered in an impressionistic way.

Tutorial **Painting fruit**

Guy Roddon has approached this traditional still-life subject with a contemporary graphic style using a combination of soft pastels and finely hatched strokes. Each shape is modelled in a variety of tones, using light, white cross-hatching to highlight certain areas and suggest the shine of fresh fruit. Colour is also used to define the form of the fruit and establish a sense of depth: by placing the melon and strawberries against the blue background, the red strawberries are 'pulled' into the foreground, with the cooler blue appearing to recede slightly.

1 The artist has roughed in the positions of the various objects by drawing light contours in the appropriate colours. Once the general design has been established, he can begin to block in colour. He continues to work fairly lightly, avoiding overfilling the grain of the paper so he can overlay more colours as needed.

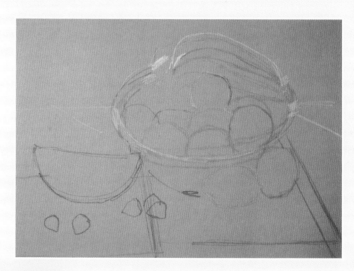

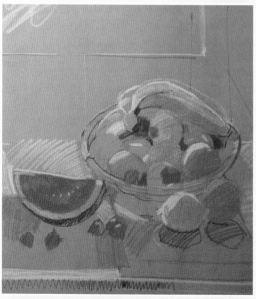

2 The fall of light is indicated with bold blocks of white pastel along the fruit and table edge. This helps to mark out highlights before getting too involved in colour and detail.

3 Because the artist kept his initial colouring-in lightly hatched, he can now begin to build up colour with other tones to bring out the forms of the fruit. Notice the attention to individual fruit textures, the addition of thin white strokes suggests the crispness of the watermelon.

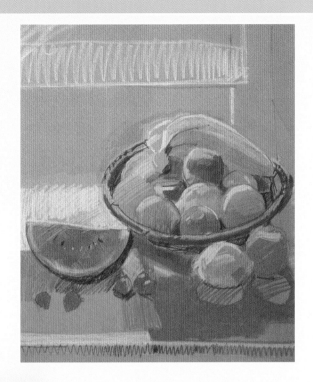

4 Now for the table top – an all-over base colour of mid-toned olive green is roughly applied, to which the artist adds darker and lighter greens to define the forms and shadows in the picture.

5 The banana is made up of a variety of yellow tones to suggest the planes of the fruit without the use of hard-edged contour. The orange tone on the underside of the banana harmonises well with the neighbouring apple.

6 To focus the eye on the brilliance of the fruit, the artist has positioned the subject against a neutral background. He builds a loose web of overlapping hatched strokes in a combination of grey, black and white.

7 More colour effects are achieved through cross-hatching. Thin green strokes on the lemon enhance the form and pick up the colours of the shadow areas. The strokes are kept quite loose to suggest the shifting movement of the light.

8 Finally, the artist softens the gradation between light and dark tones by overlapping cross-hatched strokes of light over darker blue in the foreground.

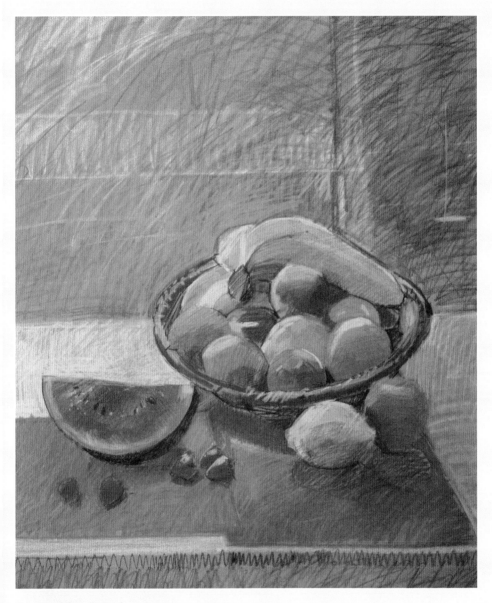

Guy Roddon *Still Life with Fruit*
In the finished picture the tones, colours and textures are nicely balanced,
with just the right amount of interest in the background. Placing red and
yellow fruit against the green and blue of the table top succeeds in
pushing the fruit into prominence and strengthening their colours, while
the quiet grey of the background recedes to its proper place.

Still life **Flowers**

Flowers are among the best-loved subjects in painting, and their vivid colours and fragile texture are ideally suited to pastel renditions. The brilliant colours of pastels match the richness of the natural flower colour range, and the variations of texture that can be rapidly achieved with the medium correspond to the variety of flower forms – soft, smooth, folded, frilled, ragged, spiky.

Cut flowers in a vase can be studied as individual blooms or as a group and you can select the container to contribute a particular quality to the design. You may choose to focus your attention on flower shapes and textures, setting them against a restrained background, or create a vivid clash with a background of active marks and strong colours woven around the flowers.

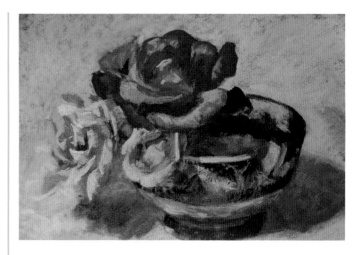

Keeping it simple

Roses have strong shapes that invite a focused treatment, but take care over the composition. The group in Rosalie Nadeau's *Chipped Bowl with Roses* gives the impression of simplicity, but it was artfully planned. The round shape and glowing colours of the bowl balance those of the flowers, and the blue shadows provide contrast.

Linear strokes

Victoria Funk uses deep, bright colours, gradually built up from a light blocking in, for this flower study. In the early stages, the colour was lightly blended, but in the final stages sharp lines were added to the petals and foliage using the pastel tip in rapid strokes.

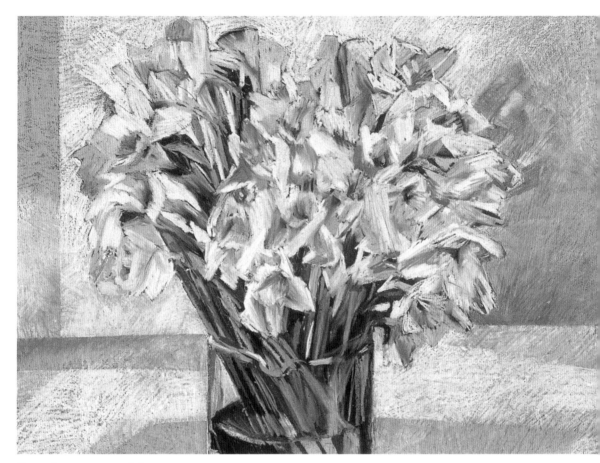

Background interest

The background of a picture should be related to the foreground. One way of establishing a link when using positive strokes, rather than smooth blends, for the flowers, is to continue them into the background. For *Narcissi*, Pip Carpenter used a dark paper that shows between strokes to emphasize them, an effect that also creates an outline effect on the flowers.

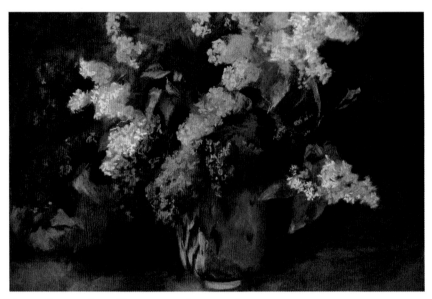

Letting the flowers breathe

In *Colour Purple* by Rosalie Nadeau, the flowers stretch beyond the picture at the top and right side. This makes them look more natural because it suggests that they have a life outside of the boundaries of the painting. The artist deliberately restricted her colour scheme to harmonious purples and blues, with white providing tonal contrast.

Working broadly

To capture flowers it can help to work in colour immediately, without making a preliminary drawing, as was done by Maria Pinschof for *Zinnias in Vase*. The artist visualized the picture by building it up in a series of lines flowing in the direction of the vase and flowers, and using scribbles in the foreground and background.

Mixing flat colour and colour gradations

The strong shapes of the flowers and foliage in Frances Treanor's *Harmony, Lily and Iris* are clearly focused by a hard-edged treatment of the individual shapes, within which colour qualities range from solid, flat colour to vibrant gradations of hue and tone. Unusually, the background hues are equal in intensity.

Still life **Floral still-life groups**

Flowers are often combined with other objects in an arranged and orchestrated still-life group. Such arrangements allow you to bring in colour contrasts and experiment with different shapes, creating a more elaborate composition than with flowers alone. However, take care not to overdo the contrasts, and choose objects that have some relationship to the flowers, so that the picture does not look disjointed.

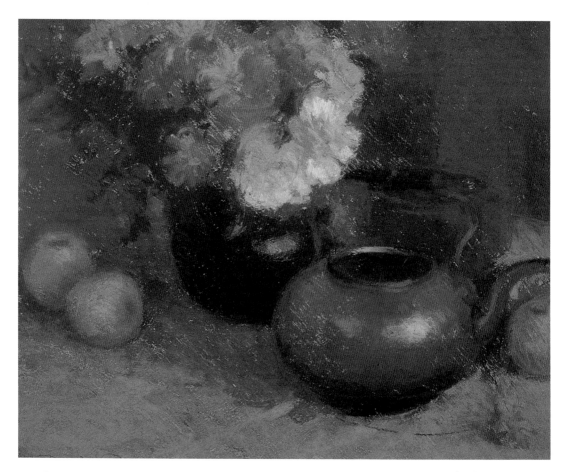

Related colour
The Table by the Window by Doug Dawson has an obvious pink-red colour theme. The flower colours are echoed in the copper kettle and touches of warm red-brown appear on the apples. The same red-brown was used to tint the paper and the artist left patches of background colour showing through, particularly in the foreground.

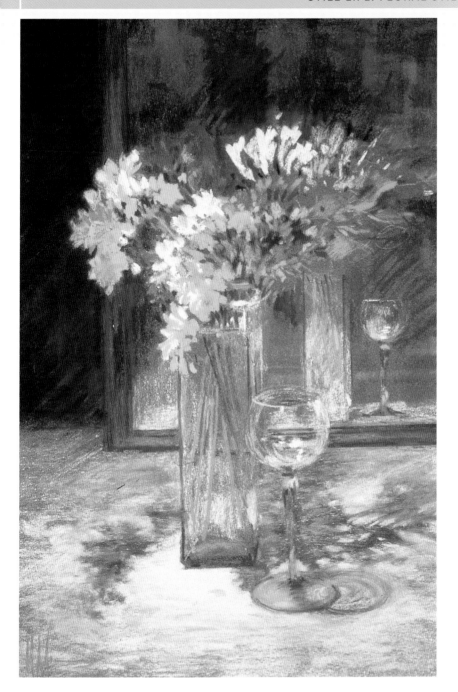

Filling in the spaces

In *Reflections I*, Maureen Jordan has solved the spatial and compositional problems posed by a tall display by bringing in some still-life objects – the wine glass and mirror – as well as making a feature of the foreground shadow. The mirror plays a double role, reflecting the glass and vase to create interest at the right of the picture, and providing a background vertical that echoes the side of the vase.

Strong colour

In Kay Gallwey's *Spring Flowers in Blue Jug* the linear style of the pastel drawing allows for a very open, active surface. The individual shapes are boldly stated and modelled with strong colour and tone, conveying both the spatial arrangement of the group and the individual forms and textures.

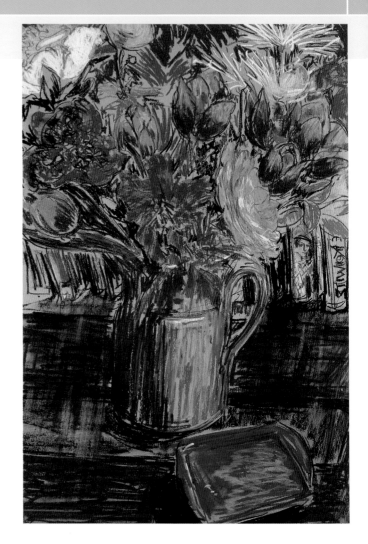

Background flowers

Often, flowers are the centre of interest in a floral still life, but in *Still Life with Frosted Blue Glass*, by Jackie Simmonds, they form a decorative background for the blue pots. There is an overall floral theme, as the blue flowers are echoed by the printed ones in the foreground cloth, where the pink provides an essential colour contrast for the predominant blues.

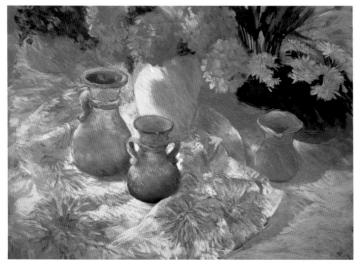

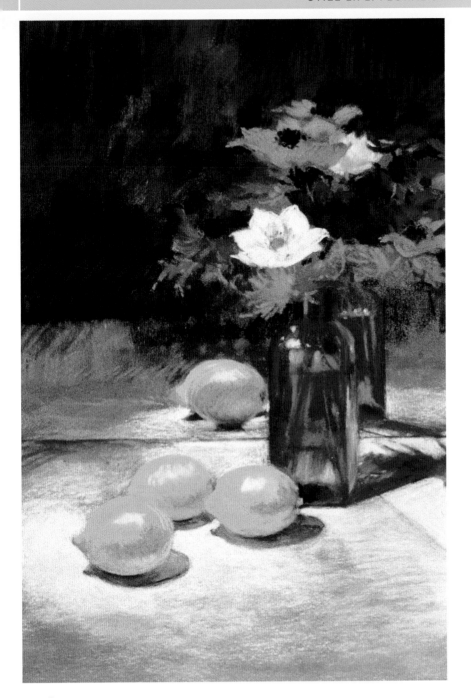

Colour contrasts

Flowers and fruit have a natural relationship, so they are often used together.
Maureen Jordan chose lemons for *Lemons in the Spotlight* because they provide
contrast for the deep, rich blues and purples. Strong tonal contrast provided by
the white flower against a dark background draws the eye to the focal point,
and the same colours are picked up in the flowers and vase.

People **Portraits**

Portraits take many forms and involve different degrees of visual analysis, but their essence lies in creating a likeness. This does not necessarily involve accurate 'copying' of a person's features, in fact sometimes the detail of the features is indistinct, or even absent, but the character of that person should always emerge.

One of the difficulties of portraiture is persuading someone to pose, since being an artist's model is quite boring. However, you can work up a successful portrait from a photograph. An ordinary snapshot can be all the inspiration you need, since candid photographs often capture a transient expression or mood that represents the person more accurately than a static pose. If you are lucky enough to have a sitter, think carefully about how you arrange the pose. Aim for a natural, relaxed look and ask your subject's advice on the most comfortable position. You will often find that this contributes to the likeness, since people have characteristic postures that they fall into naturally.

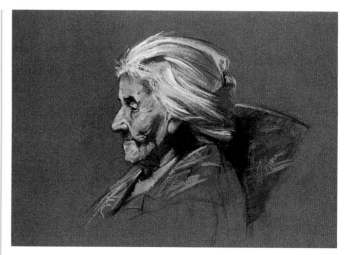

Profile

The profile view of John Houser's *Ramona (Tigua Elder)* shows characteristic features of the aged face, the sunken eyes and mouth giving prominence to the strong lines of the nose and chin. Skin tones and shadows are built up with a complex network of linear marks and shading. The warm colours and pale tints stand out on the deep blue ground, emphasizing the modelling of the profile.

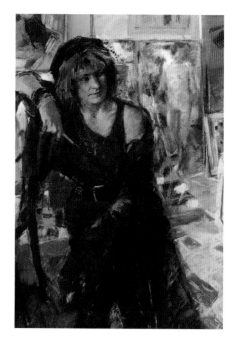

Informal pose

The informal pose of Barry Atherton's *Portrait of a Painter* gives the figure character. The dark clothing creates a solid shape, bringing the subject out clearly from the background, but even the darkest tones are alive with touches of vivid colour, every mark playing an active role in modelling the forms and creating textural variety.

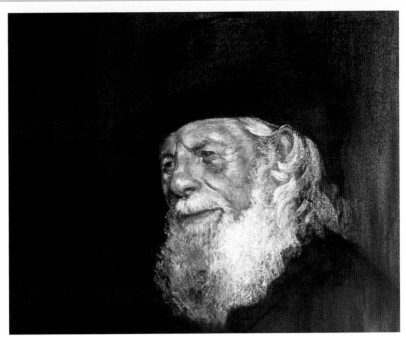

Placing the head

In a head-and-shoulders portrait it is important to consider how to place the head and from what angle to paint. Urania Christy Tarbet has used a conventional three-quarter view for *The Circuit Judge*, but in a horizontal format, with the background occupying a large part of the picture. This was because she wanted to draw attention to the head through a dramatic contrast of tone, which she further emphasized by allowing the hat and clothes to merge into the background.

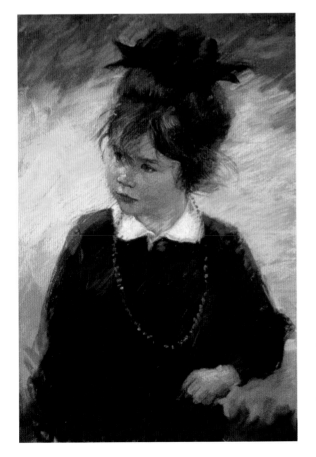

Natural pose

The outdoor setting and averted eyes of Kay Polk's *Kate* help to make the pose look natural. By choosing a half-length format, the artist was able to stress the contrast between the dark dress and the delicate colours of the skin.

Tilted pose

The slightly downward-tilted pose of John Elliot's *Young Professional* emphasizes the strong contours of the brow and nose, reinforced by the dramatic highlighting of one side of the face. The basic colour areas have been blocked in with side strokes and overlaid with hatching.

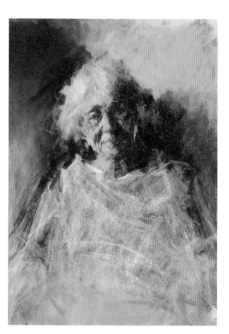

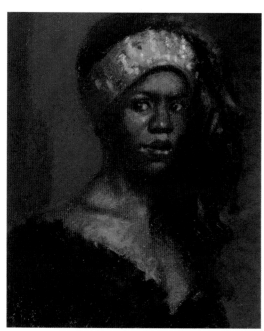

Colour balance

In his striking pastel painting *Linda*, Doug Dawson has combined a carefully planned composition with dramatic tonal contrast and exciting use of colour. The dark dress balances the similar tone of the hair, and also leads the eye into the picture, while the skin colours are enlivened with a paler version of the background colour.

Editing what you see

Aunt Emma, by Ken Paine, is an example of how the artist can edit the subject to create a more powerful effect. Treating the clothing and background in a loose and non-specific manner focuses all the attention on the face, while loosely scribbled lines still successfully describe the forms beneath the clothing. The portrayal of fragile old age is enhanced by the strange greenish light.

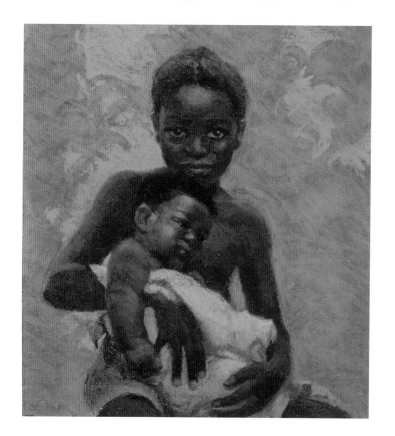

Dramatic elements

The combination of tonal contrast and the direct gaze of the older child gives pictorial drama to Doug Dawson's *Children of the Suriname Forest*. There is also a strong pattern element in the interplay of sinuous dark shapes against the brilliant background, the light green of which is introduced as highlights on the children's bodies.

Skin texture

The rugged, weatherbeaten texture of an older man's skin is represented with rich, dusky pinks and browns in John Elliot's *Salmagundian*, with fine linear marks used to convey the lining of the face and give definition to the features.

Tutorial **Painting a portrait**

In her painting *Jeremy*, Sharon Finmark has produced a portrait of considerable power. The painting relies more on tonal contrasts than on colour for its impact, with the somber browns and greys expressing a mood of quiet reflection that is backed up by the sitter's gaze: instead of engaging direct eye contact with the viewer, he looks off to one side, seemingly deep in thought. Without treating the face with an unnecessary degree of detail, the artist has nevertheless paid careful attention to the features, noting the shapes of the eyes, mouth and nose, as well as the overall shape of the head.

1 The artist begins by making a careful underdrawing using white and brown pastel pencils.

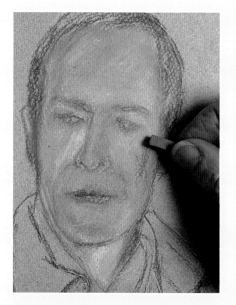

2 Everyone has their own, distinct skin colour, and it is important to identify and block this in before engaging with local variations and the effects of light and shadow. In this case, the base colour is a warm pinkish yellow, with an accent of light red on the cheekbone.

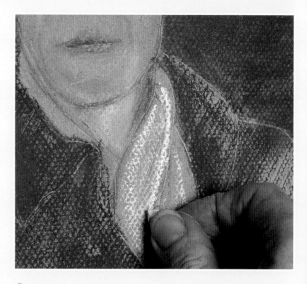

3 The artist decides that a deep, cool blue-grey background will contrast with the warm colours of the sitter's skin and jacket, so works a deep indigo over a slightly lighter colour, pushing well into the grain of the paper. She then lightly blocks in the brown of the jacket and the white cravat.

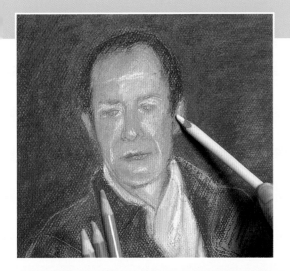

4 The paper is now fully covered and the basic tones and colours are established, so the artist returns to the face. She uses pastel pencils to pick out small linear details because these are easier to control than soft pastels and are less prone to accidental smudging.

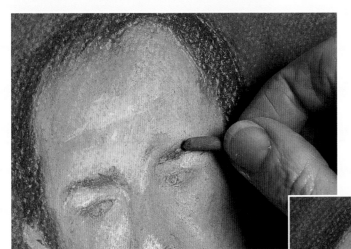

5 The eyebrows are drawn in with charcoal, which creates a softer effect than black pastel and also gives a hint of texture.

6 A grey-blue pastel pencil is used to accentuate the shadow down the side of the face, giving a stronger form to the head. The colours in shadow areas are always cooler than those in the highlights, and there is also some reflected colour from the background.

7 The chair is indicated with turquoise blue, which will later be modified with other colours. The curve of the chair provides a compositional balance for the elongated curve of the jacket while also anchoring the figure and explaining his posture. It is mainly the chair that tells us that the figure is sitting.

8 The artist now layers other colours over the jacket, gradually building up the shadows and highlights formed by the creases in the fabric.

9 The background is to be lighter on one side, partly to create additional interest and help the shoulder to stand out, and partly to explain the direction of light. White is laid over the dark colour with squiggling strokes and rubbed in with a finger.

10 The white cravat is very important to the composition because the pale shape leads the eye up to the face. The shadow of the diagonal formed by the fold of the fabric is strengthed with a grey-green pastel pencil. A blended effect is created, where the darker colour sinks into the earlier light ones.

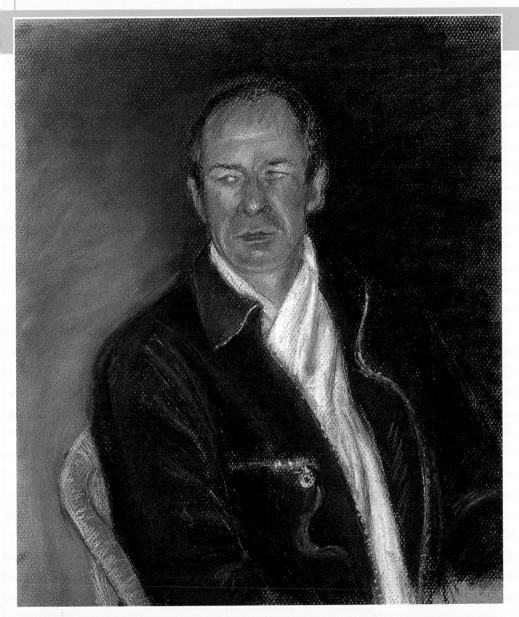

Sharon Finmark *Jeremy*

The completed composition is strong and well balanced, and the colours are sombre but far from dull. Although some blending methods have been used, the pastel marks are still visible in certain areas, providing surface contrasts that give the picture extra interest.

The placing of the head is vital in portraiture and here there is enough space above it to prevent it looking cramped, but not so much that it seems to be pushed downward. The light comes from the right, providing sufficient tonal contrast to model the forms of the face and body, and throwing the left shoulder into shadow so that it merges with the background.

People **Figures in action**

Whether engaged in sports or performing everyday tasks, people in action make an exciting painting subject. The study of a person performing a specific task may allow you to portray an unusual configuration of body and limbs, and to examine visual rhythms and tensions not expressed in formal poses. In portraying the figure in action, it is important to notice the exact angle and direction of different parts of the body that contribute to the action, and also the way clothing and props help explain the activity. You will soon learn that certain techniques give an impression of movement: for example strong linear strokes or scribbled marks are better than soft blends.

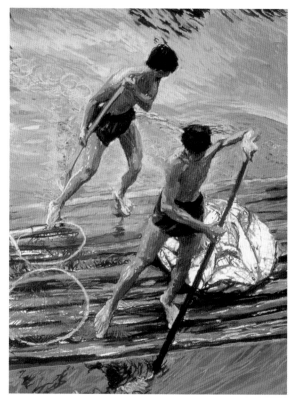

Directional strokes

When painting *Fishing, Banyan Lake*, Kitty Wallis was prompted by the relationship between the movement of the bodies and that of the water, and expressed this rhythmic flow through her pastel marks. The strokes on the figures follow the direction of their movement, emphasizing the diagonal thrust, while inventively varied marks suggest the shifting of the water.

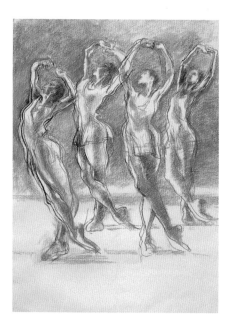

Depicting movement

In Brenda Godsell's *Dancers in Grey*, a charcoal and pastel study, the tonal balances construct the figures quite solidly, but the rapid retracing of the contour lines contributes the fluidity and rhythm of transient poses that will shortly flow into different configurations.

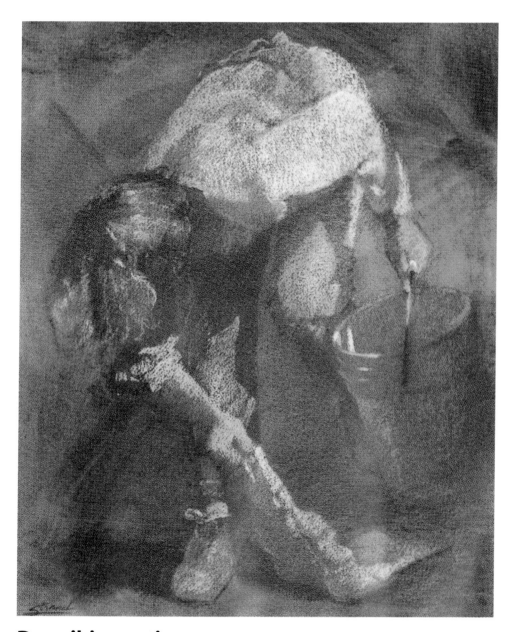

Describing action

In Sally Strand's *Nearly Overlooked*, the action is described by the contour of the body and the pattern of light and shade within it, the rhythms echoed by directional strokes.

People **Figures in context**

Describing a setting for a figure study can help to explain the character or action of the figure, as well as expand the range of compositional elements that need to be considered. New details of colour and surface texture are added to the composition, and as the figure becomes one of a number of visual components, you need to decide how to use your pastel techniques to make the figure stand out as a focal point, or to integrate it with the other elements.

The figure in a setting

When you portray a whole figure, the setting can be an important part of the picture. In her painting *3pm*, Jackie Simmonds has sensitively orchestrated the colours and all the elements of the composition. Placing her model in a relaxed pose in front of a window has allowed her to explore the effects of light and colour rather than making a deliberate figure study.

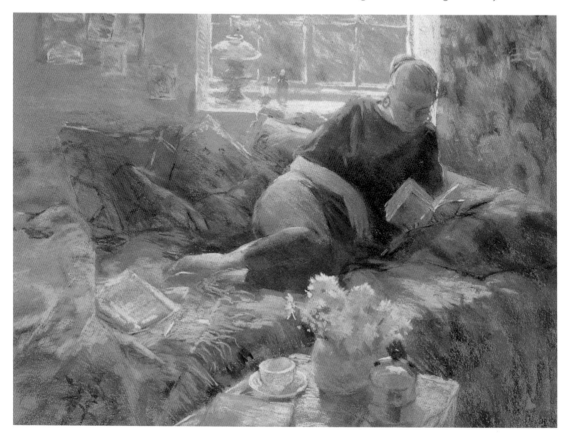

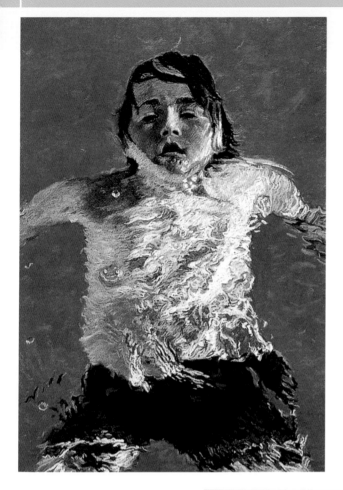

The figure in water

In *Bryan in the Pool* by Bill James, hatching is used well to depict the fragmentation of images below the surface of the water and the ripples in the water itself. The horizontal pastel strokes in the water and over the boy's body help to convey a feeling of fluidity, contrasting with the more solid shape of the boy's head above the water's surface.

Figures in a landscape

The consistent technique of combined shading and hatching in *The Beaters*, by Margaret Evans, describes the variety of form and texture, so that the figures are visually integrated with the landscape but also stand out. Pale tints overlaid on the muted, earthy colours suggest cool morning light.

Tutorial **Painting figures in a setting**

Painting a group of people in a setting can be easier to manage than a portrait or close-up figure study. Accuracy of drawing matters less than general atmosphere, good composition and well-balanced colours. Working from a photograph or a collection of quick sketches is the most likely technique in this case, and if you are working from a photograph try to interpret rather than copy. Here, a photograph has been used as a reference for some of the colours.

1 Having made an outline drawing, the artist starts to lay in the colours, starting with the darker ones, but keeping the marks light.

2 The umbrella is a dominant shape within the composition, so the artist uses a pink that is similar to the colours used on the umbrella for the seller. This links the two so the figure stands out from the background.

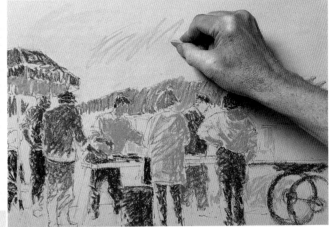

3 The sky is an integral part of the picture and the artist uses strong diagonal side strokes here to continue the sense of movement of the figures and suggest a windy day.

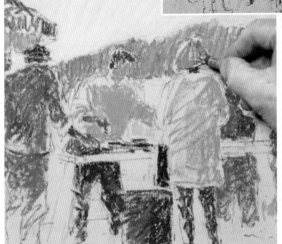

4 The strokes have been kept open so far, so colours can be overlaid without clogging the paper. The artist warms the colour of the hills with the addition of purple and adds shadow beneath the hair of one of the figures.

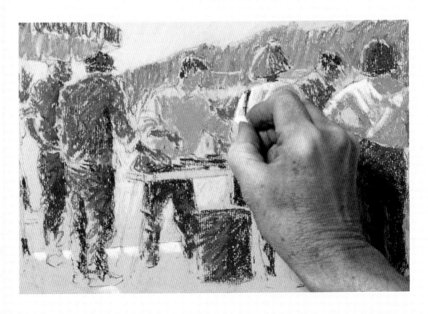

5 The artist begins to work on the highlights, using a short length of pastel for maximum control.

6 Light pinkish-brown is added to the foreground, leaving much of the grey paper showing as a second colour. Detail here would detract from the figures, but some colour is needed, along with a suggestion of perspective lines.

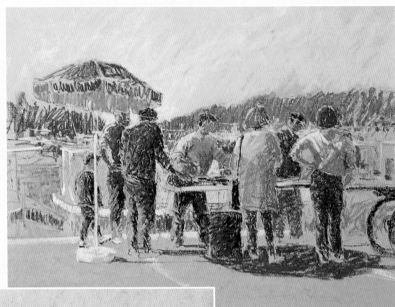

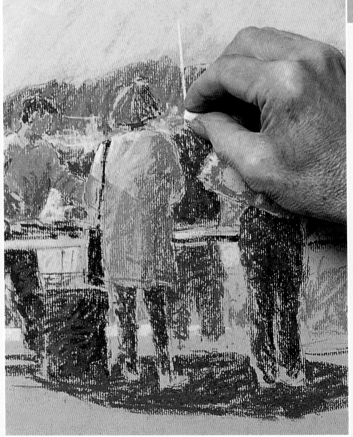

7 The central mast is drawn in. This important aspect of the composition echoes the vertical of the umbrella pole and emphasizes the upward thrust of the figures. The masts also play a descriptive role, telling the viewer that this is a harbour scene.

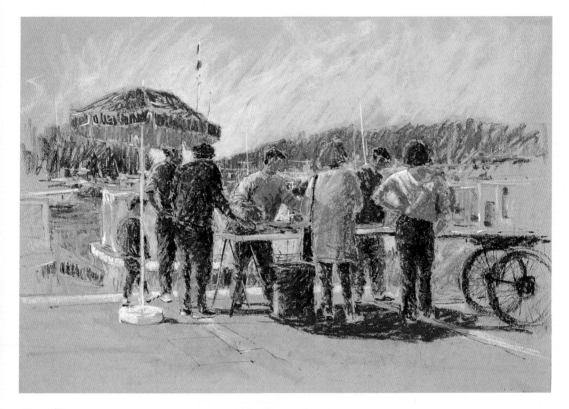

Alan Oliver

Harbour Fish Stall, France

The photograph reference has been simplified to produce a balanced composition that concentrates on the figure group and allows them to be integrated into their surroundings. Parts of the paper have been left uncovered, so that warm grey recurs throughout the picture, and pastel colours are repeated from one area to another, providing a link between the various elements of setting and figures. The central figure is a pivot in this composition, linking all the others, so he has been emphasized with a stronger colour.

People **Figure groups**

Figure groups can represent all of the visual points of interest of the single figure, but their interactions are the keynote of the image. The elements of composition in a group portrayal are particularly important, so consider the alignment of figures, the relationships of size and proportion, the space or closeness between them, and the relative distance from the viewer.

Shifting poses

The neatly aligned figure group in Sally Strand's *Corner of 48th* incorporates subtle but very different dynamic shifts in poses. Notice the solidly vertical stance of the man on the right, the slight backward angle of the woman beside him, and, in turn, the forward-leaning attitude of the man in front of her.

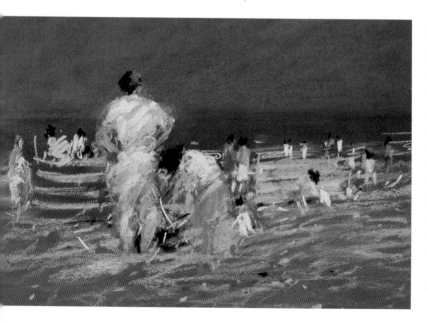

Shapes and postures

None of the figures in Alan Oliver's *A Norfolk Beach* is treated in detail, and the more distant ones are just decisive flicks of pastel. They carry perfect conviction, however, because the artist has observed the shapes of their postures so well. The figure bending over the pushchair, for example, is suggested with just a few diagonal lines.

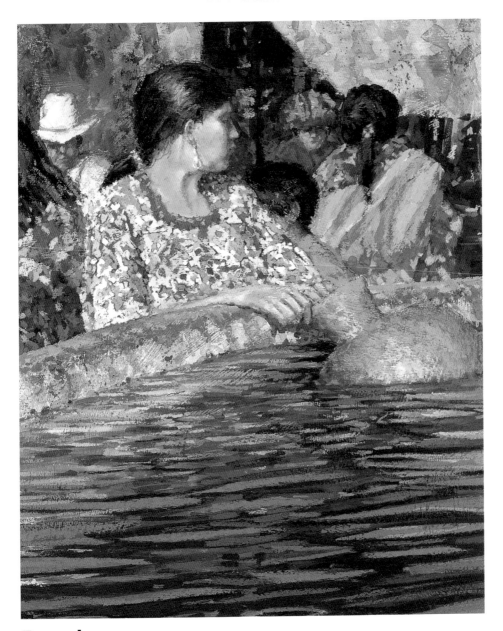

Found groups

At the Well – Chichicastenango, by Eric Michaels, shows that the randomness of figure groups can create interesting compositional elements. This close focus on forms that are cut off by one another and by the framing of the picture creates an intriguing sense of narrative as well as a vivid orchestration of colour and pattern.

Animals **Animal studies**

The range of techniques available to the pastel artist makes it the ideal medium for representing animal texture. It is suited not only to the highly tactile qualities of fur and feather, but also, the baggy, rough skins of animals such as the elephant and rhinoceros, and the smooth-haired hides of horses and cattle. An animal study is, in effect, a portrait, or likeness, of the particular animal, and it takes time to complete. The animal is unlikely to maintain one pose for the time you need, so it can be a good idea to combine live observation with photographic reference, and your own photographs are preferable to pictures from books or magazines. Making quick sketches is also an invaluable method of getting to know animal forms.

Leathery hide

Before working on *Elephant Running*, John Barber made several charcoal sketches at the zoo, paying particular attention to the way the elephant's hide folded as it moved. He has used a wide variety of blending methods for the final piece, although he took care not to blend too much, otherwise the shape of the elephant would have become too soft and rounded. Loose, scribbled strokes in places give the impression of the wrinkled, leathery hide.

Layering plumage

In *Duck at Metro Zoo*, Bill James has skilfully conveyed the soft, iridescent plumage of the duck and the gently rippling water, which both contain tiny areas of different colours, by blending and layering the pastels.

Wool texturing

The ewe's thick, rumpled wool in Keith Bowen's *The First Suckle* is elaborated with light feathering strokes and curling linear marks, the massing of the pastel marks gradually building the forms. The body of the lamb is similarly modelled, controlling the weight of the strokes and the colour range to obtain the smoother texture and brighter tone of its fleece.

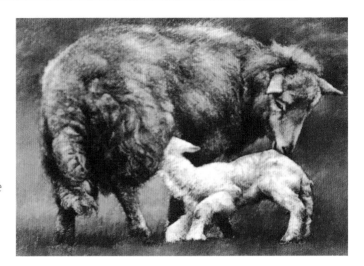

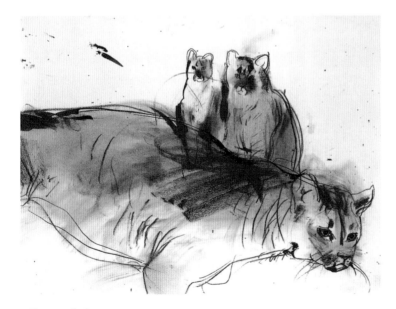

Sketching

Stan Smith sketched the loosely worked lines of *Cougars* using oil pastels, then laid in a washed colour of oil paint thinned with turpentine. The rapid movements of the pastel strokes show how quickly the sketch was drawn, focusing on the contours and skin texture of the animals' bodies, and including only the most essential features.

Tutorial **Animals in action**

For this demonstration the artist has chosen a pose full of movement and drama, and uses large sweeping strokes to really express the character of the crane. The sandpaper support chosen for the painting suits a bold, direct approach.

The artist starts by referring to quick pencil sketches he has made while on location. Sketches not only provide reference material for paintings, but making them is also a good way of training yourself to observe and record nature.

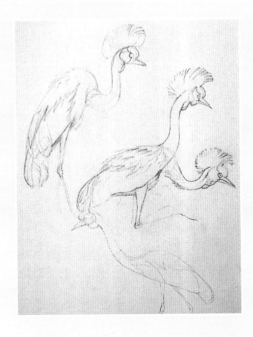

1 The artist refers to previously made pencil sketches in order to choose from a variety of poses. It can also be a good idea to make colour notes while you sketch.

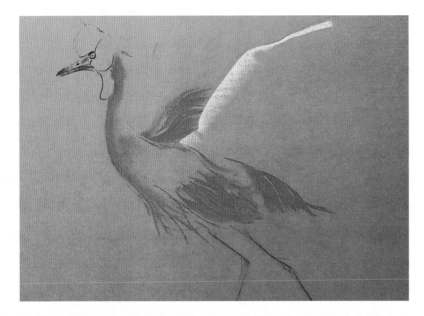

2 Accurate drawing is important for a subject like this, so the artist uses a light pencil contour to help him map out the shape of the bird. A sharp stroke of white for the wing bone gives the feeling of life and movement, and to help him describe the spread of the wing span the artist uses the side of the pastel to create large, sweeping strokes. He then fills in the main blue of the feathers by pushing colour thickly into the sandpaper support.

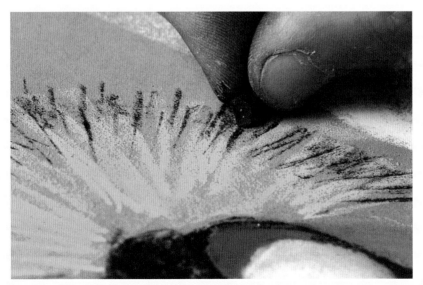

3 The soft feathers of the head are solidly blocked in, totally covering the support. In contrast, the radiating feathers of the crest are built up using small, sharp strokes that are then smudged by sliding the pastel across the sheet.

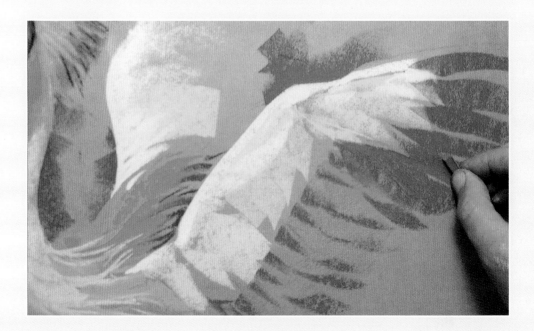

4 Using the flat edge of the pastel is a good way to describe the broader wing feathers. The sandpaper is allowed to show through the colour that is dragged across it, to create interesting textural effects.

5 The artist uses a brush to smooth in the green background, emphasizing the bird's sleek neck and fixing it in place. However, be aware that on sandpaper the brush could wear away in a short time.

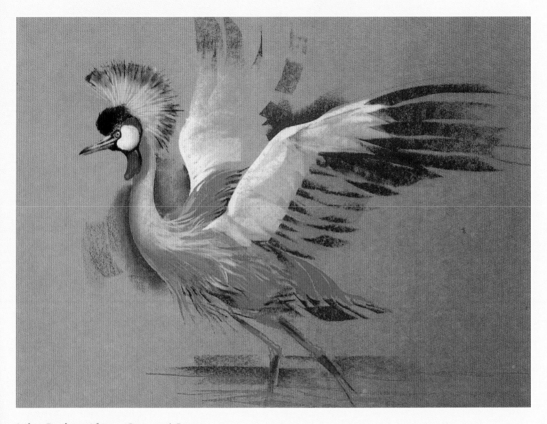

John Barber *African Crowned Crane*
The finished pastel shows a lively combination of sharp lines, dense blended areas and
light, sweeping strokes, all of which are used to suggest the different types of feathers.
The far wing has been left only lightly indicated, which helps give the impression of
spontaneity and movement.

Index

A

acrylic
 gesso 71, 112
 modelling paste 70
 paint 100, 110–111
animals 184–189
 animal studies 184–185
 animals in action (tutorial)
 186–189

B

binder 10, 11
black 36–37
blending 56–59, 126, 130, 144,
 146, 147, 153, 158, 172, 173,
 184, 189
blocking in 52, 72, 74, 76, 77,
 108, 126, 170
bread, white 18, 86, 87
broken colour 62–63, 100, 124,
 132, 142, 148
brown 36–37, 40
brushes 18, 57, 70, 86, 94–95,
 114, 188
building up 74–79
buildings 28, 138–141

C

charcoal 72, 73, 102, 103
clouds 122, 131
colour(s) 20–45
 accents (tutorial) 84–85
 balance 168
 basic palette 26–28
 broken 62–63, 100, 124, 132,
 142, 148
 colour mixes 29–37
 colour principles 22–25
 complementary 22, 23
 contrasts 124, 164, 165
 cool 22–25

 gradated 50, 61
 harmonious 23
 linking 119
 mixes 29–37
 mixing skin tones 42–43
 primary 22
 reflected 128
 related 162
 relationships 25
 secondary 22
 strong 164
 subduing colours 102
 terms 23
 tertiary 22
 using browns and greys
 40–41
 using greens 38–39
 using skin tones 44–45
 visible 101
 warm 22–25
colour wheel 22, 23
colouring the ground 68–69
complexions 42–43
cotton buds 18, 19, 59
cotton wool 86, 87
craft knife 18, 86, 87, 98–99, 112
crosshatching 64–65, 73, 109

D

depth, creating 24
diminishing size 121
drama, creating 135, 139
drawing board 18
dry pastel wash 68

E

easel 19, 48
erasers 18, 19, 86
erasing 86–87
even wash 94
experimenting 71

F

feathering 66, 130, 185
filling in the spaces 163
finger, using 56, 58, 61, 172
fixative 19, 88–89, 103
fixing 88–89
flowers 28, 82, 105, 136–137,
 158–165
foliage 136–137

G

gesso, acrylic 71, 112
gestural drawing 54–55, 124,
 136
gouache and pastel 108–109
grey 36–37, 40–41
green 34–35, 38–39

H

hand blending 56
hard edges 133, 161
hatching 64–65, 82, 94, 109,
 112, 168, 177
highlights 53, 80–83, 102, 103,
 104, 108, 110, 112, 152, 155,
 155, 156, 168, 169, 171, 172,
 179
hue 23

I

impasto 96–97
Ingres paper 14, 16
ink, water-soluble 114
intensity 23

L

landscape 28, 55, 118–137
 atmosphere and landscape
 124–125
 atmospheric landscape
 (tutorial) 126–129

composing a landscape
118–121
flowers and foliage 136–137
light and landscape 122–123
skies 130–131
trees 134–135
water 132–133
layering 107, 144, 153, 184
lead-in lines 118
leading the eye 121, 135
light 140, 177
darkness and light 134, 137
defining 80
effects of 62
evening 123
sunlight 122, 123, 127, 141
winter 123
line wash 95
linear strokes 51, 95

M

mahlstick 49
masking 92–93
masking tape 19, 92
materials 8–19
looking after your pastels
12–13
paper colours 16–17
paper textures 14–15
types of pastel 10–11
other equipment 16–17
Mi-Tientes paper 14, 16, 154
movement
describing 55, 174
water 132, 133
multi-layering 99

N

neutrals 16, 22, 25, 124, 127
'not' (watercolour paper) 14

O

orange 32–33
outdoor kit 19
overlaying 50, 76, 96, 110, 111,
139, 155
overmixing 62
over spraying 88, 89

P

paints
acrylic 100, 110–111
oil 112–113
watercolour 100, 114, 115
palette 26–28, 48
paper
colours 16–17
Ingres 14, 16
Mi-Tientes 14, 16, 154
texture 14–15, 50, 51
tissue 19
watercolour 14, 100
pastel board 14
pastel pencils 10, 11
pastels 10–11
breaking 13
charcoal over pastel 102
cleaning 13
coloured pencil and pastel
104–105
crushed leftovers 70
dust 48, 56
hard 10, 11, 75
oil 10, 11, 59, 67, 76, 86, 94,
95, 98, 105, 114, 115, 133,
185
pastel over charcoal 103
soft 10, 11, 74, 77, 94, 97, 98,
115
storage 12
tint numbers 11
patterns 62, 132, 143

P

pencils
coloured pencil 104–105
pastel 10, 11
people 166–183
figure groups 182–183
figures in action 174–175
figures in context 176–177
painting a portrait (tutorial)
170–173
painting figures in a setting
178–181
portraits 166–169
perspective 119, 121, 131, 180
preparatory drawings 72–73
pumice powder 71

R

rags 18, 19, 48, 57, 73, 76
reflections 81, 127, 128, 132,
133, 147, 148
resist techniques 114–115

S

sandpaper 13, 14, 186, 187, 188
scraping with a knife 87
scrubbed texture 113
scumbling 67, 95
secondary colours 22
sgraffito 98–99
shading 51, 83, 95, 103
shadows 73, 80, 82–85, 108,
110, 112, 122, 124, 154, 155,
158, 163, 170, 172, 173, 179
shape 55, 65, 164
contrasting shapes 120, 143
defining 81
side strokes 50, 76, 128, 129,
146, 168, 179
skies 130–131
skin tones 42–43, 44–45
smearing, avoiding 49

smudging 187
spectrum 22
stain, traditional 69
still life 150–165
 flowers 158–165
 found groups 150–151
 fruit 152–153
 painting fruit (tutorial)
 154–157
stippling 63, 68, 132, 134
surface mixing 60–61

T
temperature 22, 23, 24
textures 109, 143
 scrubbed texture 113
 skin 169
 textural contrasts 107, 108
tint chart 27
tissue paper 19
tone 23, 64, 120

'tooth' (texture) 14, 15, 50
torchon 18, 19, 58, 59, 61
trees 134–135
turpentine 11, 76, 94, 95, 185

U
underdrawing 72–73, 110, 146
underpainting 100–101, 134
urban subjects 138–149
 buildings 138–141
 depicting details 142–143
 urban landscape (tutorial)
 146–149
 urban settings 144–145

V
value 23
viewpoint 124, 135, 138, 144,
 153
violet 30–31

W
water 132–133
watercolour
 paper 14, 16
 and pastel 106–107
 tint 69
 underpainting 134
weights, varying 51
wet brushing 94–95
white spirit 11, 76, 86, 94, 95
working practice 48–49

Credits

Demonstration paintings by:
Steven Bewsher, Rima Bray, Pip Carpenter, David Carr, George Cayford, Patrick Cullen,
David Cuthbert, Ros Cuthbert, Sharon Finmark, Margaret Glass, Hazel Harrison,
Jane Hughes, Ken Jackson, Debra Manifold, Judy Martin, Alan Oliver, Christine Russell,
Guy Roddon, Jackie Simmonds, Hazel Soan and Mark Topham.

While every effort has been made to credit contributors, Quarto would like to apologize
should there have been any omissions or errors – and would be pleased to make the
appropriate correction for future editions of the book.

All other illustrations and photographs are the copyright of Quarto Publishing plc.